THE NEW DEAL IN
Orange County
CALIFORNIA

CHARLES EPTING

Published by The History Press
Charleston, SC 29403
www.historypress.net

Copyright © 2014 Charles Epting
All rights reserved

First published 2014

Manufactured in the United States

ISBN 978.1.62619.488.5

Library of Congress CIP data applied for.

Notice: The information in this book is true and complete to the best of our knowledge. It is offered without guarantee on the part of the author or The History Press. The author and The History Press disclaim all liability in connection with the use of this book.

All rights reserved. No part of this book may be reproduced or transmitted in any form whatsoever without prior written permission from the publisher except in the case of brief quotations embodied in critical articles and reviews.

*This book is dedicated to my cousin David,
my New Deal partner in crime.*

Contents

Acknowledgements 7
Introduction 9

1. An Overview of the New Deal 11
2. Coastal Orange County 18
3. Northern Orange County 42
4. Central Orange County 69
5. Southern and Eastern Orange County 101
6. Other New Deal Projects in Orange County 111

Appendix: Orange County's Most Important Pieces of
 New Deal Art and Architecture 123
Additional Reading 137
Index 139
About the Author 143

Acknowledgements

First and foremost, I'd like to thank everyone who supported me during the research and writing process, including my parents, my sister, my nana, my fellow USC students and my brothers in Theta Chi fraternity—without your constant enthusiasm and encouragement, this book never would have been possible. I'd also like to thank everyone who joined me on my explorations of Orange County's New Deal landmarks, most notably my parents and Chelsea Exton.

I would also like to thank the Orange County Archives, Brea Historical Society, USC Libraries, University of Irvine Special Collections, University of California Libraries, Huntington Beach Public Library, Anaheim Muzeo and anyone else who assisted me in my research.

Introduction

The New Deal is something of which many people have heard, but few actually understand its nuances. In the most general sense, the New Deal is the summation of all of President Franklin Delano Roosevelt's domestic programs to combat the Great Depression. In history class, we're taught about the New Deal's "alphabet soup" of organizations—the WPA, CCC, TVA, SSA, NRA—but keeping all of these organizations straight is exceedingly difficult, especially given how similar some of the acronyms are (the WPA versus PWA comes to mind).

While the New Deal consisted primarily of nationwide programs, it is a story that can also be told on a local level—and can perhaps be understood much better when looked at in this way. Hearing that the WPA spent $11.4 billion while it existed makes the organization seem huge and unapproachable when looking at it from a historical standpoint. However, actually visiting a building constructed by the WPA and seeing how it impacted the surrounding community when the country was in the midst of its worst financial situation ever helps one to understand what the New Deal is all about.

Having lived in Huntington Beach for the majority of my life, it seemed natural when I first learned about the New Deal in history classes to try to figure out how the various programs touched the places with which I was so familiar. Once I learned what types of art and architecture to look for, I began finding remnants of the New Deal everywhere I looked. Wherever I went in Orange County, it seemed that there was always a school, library, post office or other public building constructed during this era.

Introduction

The more research I did, however, I began to realize there was no comprehensive guide to how the New Deal impacted Orange County. Several articles mentioned the more well-known sites, but I quickly found out that there was much more than met the eye. Furthermore, there was a large amount of confusion regarding who built certain buildings—every New Deal structure was referred to as "WPA," even if it had been built before the WPA came into existence.

This book is the product of a long journey of sifting through old newspapers and books, visiting all of the sites and determining which buildings were built during the New Deal, who designed and constructed them and how they helped to revitalize Orange County during the Great Depression. Hopefully it will serve as a guide for similar books on other communities, as the story of the New Deal is one that should be told in each city, town and region it affected.

So with that, I invite you to travel with me back to the era of Roosevelt as we explore what Orange County was like during the New Deal.

CHAPTER 1

An Overview of the New Deal

When President Franklin Roosevelt took office on March 4, 1933, the country was in the midst of the worst economic situation it had ever faced. After the stock market crash of 1929, unemployment skyrocketed to 25 percent, poverty reached record levels, banks struggled to stay open and nothing the government did seemed to make it any better. Roosevelt, however, had a plan. During his first one hundred days in office, he rolled out the New Deal, a series of government programs, relief agencies and financial reforms aimed at restoring the economy and providing relief for families who most needed it. Diverse entities such as the Federal Deposit Insurance Corporation (FDIC), Social Security System and Federal Housing Administration were all products of FDR's New Deal.

The particular parts of the New Deal with which this book is concerned are the government relief agencies created to help provide jobs (as well as municipal infrastructure) at a local level. Of all of the agencies created to serve this purpose, the most famous today are the Works Progress Administration and Civilian Conservation Corps; however, these agencies are just two of many that were established to provide employment to out-of-work individuals.

One of the earliest such agencies was the Public Works Administration (PWA). The PWA was founded in June 1933 by the National Industrial Recovery Act (NIRA), which also created the National Recovery Administration (NRA). The director of the PWA was U.S. Secretary of the Interior Harold L. Ickes.

Some confusion exists around the PWA, given the similarity of its acronym to the much more famous WPA. The PWA's role was to provide money to hire private contractors to construct public works projects (the WPA, on the other hand, provided labor and materials). Typically, the PWA would finance 45 percent of a project's cost, leaving the local government responsible for the other 55 percent. Over the next eight years, the PWA spent more than $6 billion nationally before being abolished in June 1941.

The Federal Emergency Relief Administration was a much shorter-lived counterpart to the NIRA. The main program administered under the FERA was the Civil Works Administration, which existed only from November 8, 1933, to March 31, 1934. In less than five months, the CWA spent approximately $1 billion and employed 4 million Americans. A special segment of the CWA called the Public Works of Art Project (PWAP) was the first New Deal agency to employ out-of-work artists.

By 1935, Roosevelt began to unveil his "Second New Deal," which featured more extreme measures to combat the Depression. The keystone to this program was the Works Progress Administration, founded on April 8, 1935 (and renamed the Work Projects Administration in 1939). Harry Hopkins was the agency's head. Aimed primarily at providing jobs for laborers (and specifically heads of families), the program spent $13.4 billion and provided almost 8 million jobs before being dissolved on June 30, 1943.

In addition to the vast amounts of construction work undertaken by the WPA, there were also programs for artists, writers, youths and women who had not worked before this time. Books and plays were written, clothes were sewn and school lunches were provided. Most notably in Orange County, the Federal Art Project (FAP) provided several public works of art aimed at increasing morale during the darkest days of the Depression.

Prior to the FAP, a separate organization, the Public Works of Art Project, existed under the direction of the U.S. Treasury. As a general rule of thumb, any public art produced in 1934 was a result of the PWAP, while anything made from 1935 until the end of the New Deal was done by the FAP. To make matters even more confusing, post office murals were commissioned by a third agency, the Section of Painting and Sculpture of the U.S. Treasury Department.

One last federal government relief agency that had an impact in Orange County was the Civilian Conservation Corps, colloquially known as the CCC. In operation from 1933 to 1942, the CCC employed unmarried men between the ages of eighteen and twenty-five. These unskilled laborers were deployed to national, state and local parks in order to conserve and develop

An Overview of the New Deal

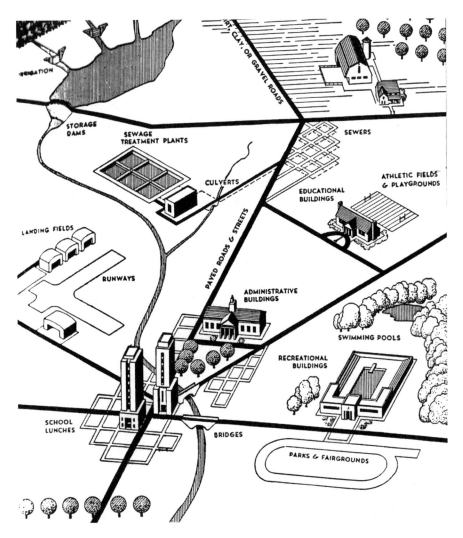

This graphic was produced by WPA artists to show the public what the organization was doing to help solve unemployment during the Depression. Orange County received examples of nearly all of the categories depicted during the New Deal—most numerous were schools, administrative buildings, sewers and parks.

the natural resources for everyone to enjoy. Each man received thirty dollars every week, of which twenty-five dollars was sent back to their parents.

The CCC was the most popular of all of the New Deal agencies among the general population. CCC workers planted trees, beautified over eight hundred parks across the country and constructed roads and

fire stations—leading many citizens to discover the natural resources this country has to offer. Due to the shortage of young men during World War II, the program had to be stopped; however, several agencies today follow the CCC's model for providing young men with parkland jobs.

Not all relief agencies were administered by the federal government. In the state of California, the State Emergency Relief Administration (SERA) served a similar role as the FERA. Like the FERA, the SERA would administer funds and provide workers for various projects throughout the state.

Ever since President Roosevelt enacted his New Deal, historians and economists have debated whether the programs were successful. The sudden onset of U.S. involvement in World War II on December 7, 1941, prevented many of the long-term effects of the New Deal from being seen. This book does not take a political stance one way or the other—regardless of the political divide (both in the 1930s and today), these government agencies still contributed massive amounts of infrastructure to the United States (and Orange County in particular), and the sole purpose of this book is to document these landmarks.

New Deal projects are in a strange place at the present time. Although some, such as Coit Tower in San Francisco and the Griffith Park Observatory in Los Angeles, are celebrated historic and architectural landmarks, a vast majority are not typically viewed as old enough to be celebrated and preserved. Very few of Orange County's New Deal buildings are listed on the National Register of Historic Places, yet most public buildings constructed in the 1920s or earlier are listed. This is also presumably due to the vast number of structures built during this period—when so many cities were receiving post offices, schools and libraries, few stand out as special.

Given that the entirety of Orange County had only approximately 120,000 residents in the 1930s, it may come as a surprise that it received so much governmental assistance (for comparison, Anaheim has nearly three times that many people today). However, several factors created the "perfect storm" for New Deal spending in Orange County—by some measurements, spending was higher per capita than in Los Angeles and San Diego Counties.

The first major event that contributed to New Deal spending was the devastating Long Beach Earthquake, which took place at 5:55 p.m. on March 10, 1933 (only six days after President Roosevelt took office). The earthquake, with a magnitude of 6.4, caused upward of $50 million worth of damage and claimed 120 lives. Had the earthquake taken place during work and school hours, the number of deaths would have been much higher.

An Overview of the New Deal

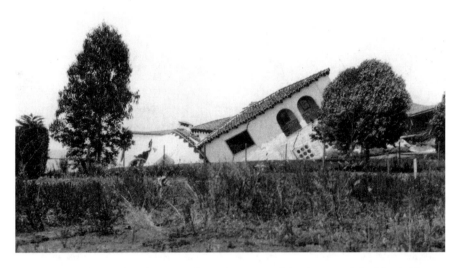

This photograph from San Clemente shows the extent of the damage of the March 10, 1933 Long Beach earthquake. The earthquake, which came only days after the start of President Roosevelt's New Deal, provided Orange County with countless opportunities to spend government relief money. *Photo courtesy USGS.*

Although named after Long Beach, Orange County received just as much (if not more) of the impact from the earthquake. In some cities, every brick building was completely destroyed. The sudden need for infrastructure—city halls, libraries, police stations and post offices, to name a few—could not have come at a better time for the county. The government was looking to distribute money at the very time Orange County needed it most.

Another impact of the earthquake was the passage of the Field Act on April 10, 1933, which mandated that all schools in the state must be earthquake resistant. Because of this, an estimated 230 schools across Southern California were rebuilt, remodeled or completely demolished. Several of Orange County's most impressive New Deal landmarks are schools that were built in response to the Field Act.

The next tragedy that necessitated government relief was the 1937 Santa Ana flood. Over the course of February 4–7, some places in Orange County received eight inches of rain (which happens only about twice each millennium). The following year, between February 27 and March 3, two cyclones hit Southern California; although this is referred to as the Los Angeles Flood, experts agree that Riverside and Orange Counties received the worst of the flooding.

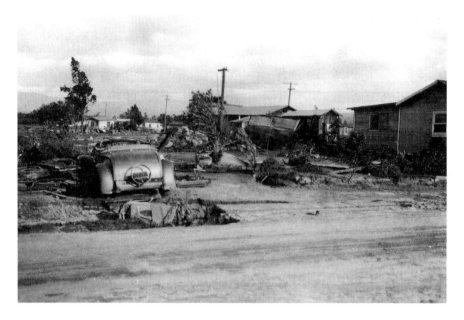

Only five years after the Long Beach earthquake, Orange County was hit by the worst flooding the region had experienced in decades. As was the case with the earthquake, government relief programs helped to restimulate Orange County's agriculture-based economy, as well as provided infrastructure to prevent such floods in the future. *Photo courtesy Orange County Archives.*

The 1938 flood caused $40 million of damage and killed at least 113 people across Southern California. The Santa Ana River swelled to half the flow of the Mississippi River, 317,000 cubic feet per second, and cities like Anaheim and Santa Ana were flooded with six feet of water. Small communities like Atwood were devastated by the flooding, and agricultural fields (which formed the backbone of Orange County) were destroyed by the large amount of silt brought by the river.

On September 25, 1939, yet another disaster struck Orange County—the only tropical storm to hit California during the twentieth century. Although landfall was made in nearby San Pedro, several piers and coastal buildings in Orange County were destroyed. Having three such devastating natural disasters in consecutive years destroyed much of the infrastructure that had been spared by the 1933 earthquake and also led to the passage of flood control legislature that sparked a new wave of construction.

Because of these disasters, nearly every single community in Orange County was profoundly impacted by the New Deal. Dozens of schools, city

halls, post offices, parks, libraries and fire stations were built; roadways were improved; and thousands of men were given jobs. But these weren't the only impacts of the New Deal—women in some of the larger cities were given jobs sewing clothes for needy families, nursery schools were established and staffed by government workers, archeological excavations were carried out throughout the county and historic buildings were documented. Almost every facet of life was impacted by the government's involvement during this time.

Never before has a comprehensive survey of all of Orange County's New Deal public works—as well as other economic programs from the time—been undertaken. Several such structures have already been lost to time, but many more are still standing today, some lacking any kind of designation or recognition. Inside the pages of this book exists the most complete record of Orange County's public works between 1933 and 1942 ever compiled. For each city, I have compiled architectural, historical and cultural details about each New Deal landmark I was able to identify.

However, this record is inevitably incomplete. Some buildings are celebrated local landmarks, with every aspect of their history documented and available. For many structures, though—particularly those that no longer exist—there is next to no information available. Santa Ana's City Hall is federally listed as a historic landmark, and a vast number of photos and firsthand documents exist chronicling its history. Nearby, however, is Edison Elementary School, which was built during the exact same time but mentioned in only one or two newspaper blurbs from the era. Both were funded by the same government agency, both impacted the same community and both are outstanding examples of Art Deco architecture—yet one is famous, and the other is forgotten.

In cases such as these, I have done my best to include as much information as possible, even if it is nearly nothing. For this reason, there is a large disparity in the amount of space dedicated to certain cities and buildings. This is not a bias on my part but a bias in the historical record regarding what information has been preserved. In the future, new facts will undoubtedly emerge regarding some of these buildings, but at the present time, every resource available has been exhausted.

CHAPTER 2

Coastal Orange County

Seal Beach

Seal Beach's first pier was constructed in 1906; it was the longest pier south of San Francisco at the time. Between 1916 and 1930, the public was not allowed on the end of the pier, due to the presence of fifty high-voltage "scintillator lights" purchased from the 1915 Panama-Pacific International Exposition in San Francisco. These lights put on a dazzling multicolored light show on summer nights that could be seen from twenty miles away. A roller coaster from the exposition was also installed, and bathhouses, a café and dance halls were constructed during this time.

However, with the onset of the Great Depression, Seal Beach's growth during the 1920s rapidly slowed. Time finally took its toll on the old pier when, on the night of July 2, 1935, a strong high tide destroyed a forty-foot section of the wooden structure. Twenty people were stranded at the end of the pier, and a U.S. Coast Guard ship had to be called in to rescue them. In the wake of this near-tragedy, Seal Beach quickly began planning a complete refurbishment of its oceanfront. By July 1936, the old roller coaster, café and bathhouses had been razed in anticipation of new facilities.

Although plans for a citywide improvement campaign (including a new pier) were laid out in 1936, the Depression halted any further planning until March

3, 1938, when Seal Beach's city council recognized that the "public interest and necessity demand the…construction of a municipal pier." With an estimate of the project's cost set at $101,500, the city put the issue up for a public vote on April 12 of that year. Overwhelmingly, the public supported the new pier, with 507 supporters compared to only 97 opponents. Quickly, the city purchased the old pier and demolished its "rotted, barnacle-crusted skeleton."

By the beginning of May, Victor W. Hayes had been hired as the consulting engineer on the project, and on May 19, 1938, the city of Seal Beach filed for federal financial aid. At this time, there were also plans for the construction of a new civic auditorium, bathhouse, plunge and dance hall, but ultimately funding was granted for only a pier. On August 22, the Federal Emergency Administration of Public Works authorized project No. Calif. 1723-F, promising the city 45 percent of the project's costs (up to $49,090). Seal Beach's city council hastily accepted the offer on September 1. The City of Seal Beach also sold sixty $1,000 bonds to cover the remaining cost.

Seal Beach accepted the Ansco Construction Company's bid to reconstruct the pier, and construction began in October. As specified by the PWA, construction on the pier was completed by April 14, 1939, with a final price tag of approximately $110,000 (slightly over the estimated cost). May 19, 20 and 21 were set aside for the official dedication of the pier; festivities included a bathing beauties contest, boat races, an air circus, marching bands and an all-day fishing competition. At 1,865 feet, only Oceanside's wooden pier was longer in California. What also made Seal Beach's pier unique was the fact that it featured drinking fountains, restrooms and electrical wiring.

After the city raised its initial $60,000, $41,000 of additional bonds were sold; with this excess money, Seal Beach purchased the land surrounding the base of the pier to develop into a park. On June 28, 29 and 30 of 1940, Seal Beach held its second annual Beachcombers' Frolic, which featured the dedication of the new park (including a picnic area and playground).

The PWA's 1939 wooden pier continued to stand until 1983, when large pieces of it were demolished by a storm on March 2. After a two-year "Save the Pier" campaign, the Seal Beach pier reopened in 1985. Today, the concrete base of the pier (at Main Street and Ocean Avenue), as well as its ornamental streetlamps and restrooms, is original to the 1930s. A plaque near the front of the pier still commemorates the role the Federal Emergency Administration of Public Works played in its funding and construction.

Although the pier was arguably Seal Beach's largest New Deal project, it was by no means the city's only one. As early as February 1934, Seal Beach sent proposals to the Civil Works Administration for the construction of a railroad crossing at

The Seal Beach Pier as it appears today. When it was constructed (using PWA funding), it was the second-longest wooden pier in California. Although the wooden part of the pier was replaced after a storm in the 1980s, the concrete base of the pier is original. A plaque mounted on the base of the pier commemorates the PWA's involvement. *Photo taken by the author.*

Constructed between 1934 and 1935 for a cost of about $53,000, Seal Beach Elementary School was closed in the 1990s and converted to retail space. The wall in the foreground is made of bricks from the original elementary school destroyed by the 1933 earthquake. *Photo taken by the author.*

Twelfth Street; new sidewalks, curbs and gutters; and a public restroom. However, the CWA's dissolution the following month ended any hope for these projects.

Another of Seal Beach's major public works projects during the New Deal was the construction of the breakwater on either side of Anaheim Landing Bay, located on the southern end of the city. Anaheim Landing, one of Orange County's oldest settlements, had been used as a harbor since its founding, but the construction of two jetties would allow for it to be developed further and make the port much more useful.

On March 29, 1935, Seal Beach residents approved a bond issue for the breakwater, at the suggestion of Victor Hayes (who would go on to supervise the pier's construction). PWA support came on January 29, 1936, and by mid-1936, the project was well underway. The 615 tons of rock required for the project cost only $1,415, but the combined cost of the entire project ended up totaling $82,000. Today, the two jetties continue to protect Anaheim Landing Bay.

There is another Seal Beach landmark from this era that has all but been forgotten in recent years; indeed, many people probably drive past the small retail center located at Pacific Coast Highway and Twelfth Street without realizing that it is the remains of an elementary school constructed in the wake of the 1933 earthquake. The original Seal Beach Elementary School, built of brick, was severely damaged by the earthquake, and RFC workers quickly got to work dismantling the ruins.

Within the first few weeks following the disaster, the architectural firm of Marsh, Smith and Powell was hired to design a replacement—this time constructed of reinforced concrete. The new complex would contain administrative offices, a library, an auditorium and classrooms for 350 students. Seal Beach school superintendent J.H. McGaugh himself traveled to Sacramento to secure governmental aid, and a bond election to raise money was held in June 1933. Construction was begun in late 1934 at a cost of $53,440, and the school was completed the following year.

Seal Beach Elementary School, which was later renamed Mary E. Zoeter School, served the community for many years until it was finally closed in the 1990s due to declining admissions. Due to asbestos concerns, most of the classrooms were demolished, but remnants of the school remain today—the administration building has been converted to retail space along Pacific Coast Highway (1190 PCH), and a small segment of the classrooms building is now a preschool at the corner of Twelfth Street and Landing Avenue. Perhaps the most significant part of the property, however, is the brick wall that runs around the perimeter—it was constructed from bricks salvaged from the original school that was destroyed in the earthquake.

Huntington Beach

Located to the immediate south of Seal Beach, Huntington Beach experienced a huge population boom following the discovery of oil in the city in 1920. By the time the Great Depression hit, the city was home to 3,600 people; but despite not having that large of a population, the city was one of the largest recipients of New Deal aid in the county. During the 1930s, Huntington Beach became home to a new elementary school, fire station, pier and recreation hall, while other civic buildings and parks were also updated by relief agencies.

Most of the new development in Huntington Beach was due to the devastation caused by the 1933 earthquake. One building that was hit particularly hard was Huntington Beach Grammar School, located at the corner of Palm Avenue and Fourteenth Street. Contemporary reporters said that the damage suffered was greater than any other school in the county. Also known as the Central Grammar School, the striking Classical Revival structure had been dedicated in February 1916 at a cost of $50,000. The earthquake, however, leveled all four walls of the school's main building. The state-of-the-art gymnasium and pool, which had been dedicated adjacent to the school on October 1, 1931, escaped the earthquake almost entirely unharmed.

In the aftermath of the tragedy, W.J. Bristol, the president of the elementary school board, declared that the monetary loss suffered in Huntington Beach was greater than that suffered by any other school in the county. Because the earthquake struck in the evening, there weren't any children in the building at the time; however, night watchman J. Williams narrowly escaped with his life, having to dodge hundreds of falling bricks.

Plans quickly had to be made regarding how to continue the school year in the absence of a school. It was decided that kindergarten classes would be held at the Standard Oil Recreation camp, first-grade classes would be at the Women's clubhouse, grades two through six would have class inside the gymnasium next to the school and seventh and eighth grades were transferred to Huntington Beach Union High School. Within a month after the earthquake, construction crews were already removing any usable equipment from the rubble.

By mid-April, the Reconstruction Finance Corporation was paying for workers to tear down what was left of the buildings. At the same time, the elementary school board hired architects James E. Allison and David C. Allison, who had previously designed Huntington Beach High School, to design the new school. Work began immediately on reconstructing the

cafeteria and home economics building; this building, which was ready for school use as early as January 2, 1934, continued to stand just south of the main school building until it was torn down in January 1991.

The school board estimated the cost of a new elementary school building to be $200,000. In early March 1934, the CWA made a $52,420 grant toward the total; the remaining cost was financed by the state on the basis of long-term loans. When the project was completed, the cost was closer to $280,000. Although initial plans called for the school to be constructed in time for the 1934 school year, political gridlock prevented construction from beginning until August 2, 1934. The construction time was estimated to be nine or ten months; in the meantime, a team of thirty-three State Emergency Relief Administration workers cleared debris in order to landscape the grounds around the school.

Throughout August and the following months, work continued on the impressive new elementary school building. Allison & Allison's design was a monumental form of Art Deco architecture very popular at the time. A steel frame and poured concrete ensured that the two-story building would be resilient against any future earthquakes, and thirty-six classrooms and an auditorium were designed to accommodate one thousand students. The last of the building's concrete was poured on December 27, 1934.

Immediately following its construction, the Huntington Beach Grammar School's modern design became celebrated throughout the state. So revolutionary was the design that the California State Department of Education displayed a photograph of the new building at the 1935 California Pacific International Exposition in San Diego as the new gold standard for earthquake-proof design of public schools.

The newly designed auditorium opened its doors on June 7, 1935, for the graduation ceremony of the eighth-grade class, and in fall of that year, the school itself opened for 741 students. Soon after the first day of school, an open house was held for the community, showcasing the new facilities to 500 local residents. Completing the school's beautification, a $20,000 Works Progress Administration project was begun in November 11, 1935, that involved the planting of ornamental trees, the grading of school property and the installation of sidewalks.

The school has since been renamed Dwyer Middle School, after former assistant principal Ethel Dwyer (whose ghost still allegedly haunts the school). Controversially, solar panels were installed on the school's front lawn in 2011, causing many local residents to protest. However, the school itself still maintains all of its architectural integrity and is without a doubt one of the most important New Deal landmarks in the entire county.

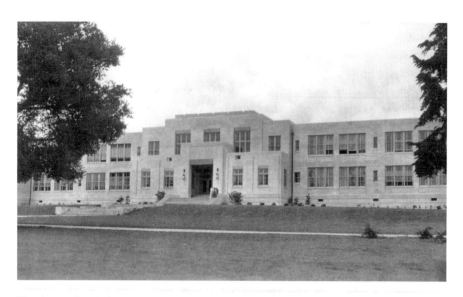

Huntington Beach Grammar School, now Dwyer Middle School, as it appeared around the time of its construction in 1935. The building, which cost $280,000 to construct, was heralded as one of the most state-of-the-art schools in the entire state. *Photo courtesy Orange County Archives.*

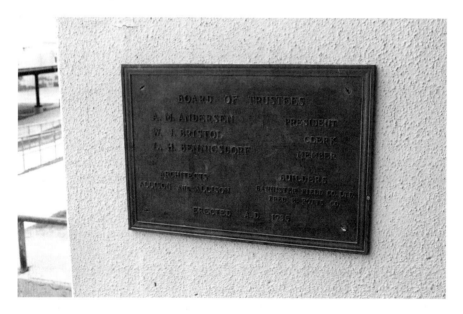

A plaque on Dwyer Middle School lists the men responsible for the building's construction. Allison & Allison's design was considered so beautiful that photographs of the school were exhibited at the 1935 San Diego California Pacific International Exposition. *Photo taken by the author.*

The elementary school was not the only school in Huntington Beach to receive federal aid; Huntington Beach Union High School was also the recipient of a new industrial arts building. Allison & Allison had designed the school's historic auditorium in 1926 and were again hired in 1937 to design a replacement for the former manual arts building, located directly behind the auditorium. Their plans were submitted in July 1937, with an estimated cost for the new building set at $75,000. Completed the following year, the actual price of the structure was $78,198. Although many of the high school's historic buildings have been demolished in more recent years, the New Deal industrial arts building is still standing.

Other government buildings were also affected by the 1933 earthquake. In 1923, the Huntington Beach civic center was founded downtown between Orange Avenue, Pecan Avenue, Fifth Street and Sixth Street. Albert R. Walker and Percy A. Eisen designed a brand-new city hall and memorial hall for the city, the latter of which was replaced in 1931 by a more modern Art Deco building. Both of these buildings were so damaged by the earthquake that city officials had to move their offices into tents until workers could repair them and engineers declared them safe for occupancy.

In 1939, both of these buildings were again refurbished using government aid, although their outward appearance remained very much the same. When Huntington Beach constructed a new civic center in 1974, the old buildings became obsolete and were quickly demolished. Two Art Deco eagles that formerly graced the façade of Memorial Hall, as well as the state and city seals that were formerly above the door of the old city hall, were rescued from demolition and currently reside in the city public works yard on Gothard Street.

Immediately north of Memorial Hall, at the northwest corner of Fifth Street and Pecan Avenue (an intersection that no longer exists due to rerouting of the roads but is approximately where Sixth Street crosses Main Street today), another building was added to the civic center complex in 1939. The fire department, which had formerly been based out of city hall, had a new station constructed at a cost of $30,000. Labor was provided by the WPA, and the city had to spend only $7,500 on materials. Built in the Streamline Art Deco style, the new fire station was one of the most unique buildings in Huntington Beach at the time. Graceful curves characterized the structure, which was very similar to the Pav-A-Lon ballroom built the previous year, and the bell from the city's first fire station was mounted onto a concrete pedestal. When the building was torn down along with almost all of the rest of the civic center, the bell was moved to the Lake Fire Station

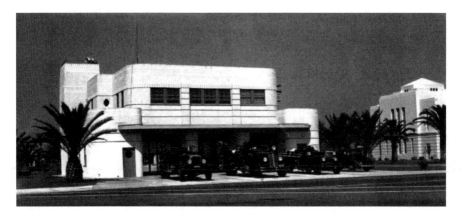

Huntington Beach's WPA fire station was constructed in 1939 at a cost of $30,000. The building was one of the few Streamline Moderne buildings constructed in the county. In the distance, Huntington Beach's Art Deco Memorial Hall can also be seen.

two blocks away. The loss of the 1939 fire station represents one of the greatest losses of architecture in the city, as there are no surviving buildings of this style.

In nearby Lake Park, a $6,500 recreation building was designed in 1937; the park itself also benefited from extensive landscaping throughout the course of the 1930s. Dedicated on April 9, 1938, the building provided meeting rooms for local Boy Scouts, Girl Scouts, fishing clubs and other civic organizations. The U-shaped building still stands in the eastern part of the park, adjacent to the 1923 Boy Scout cabin.

One of Huntington Beach's most beloved historic landmarks is the post office located on the southeast corner of Main Street and Olive Avenue. A product of four years of grassroots public support and political red tape, the building stands as a testament to the determination and steadfastness of many of Huntington Beach's early civic and social leaders.

In many ways, the story of the post office begins with the appointment of J. Ed Huston to the position of Huntington Beach postmaster in August 1933. Huston, a former city councilman, was well aware of the city's need for a new post office and alongside chamber of commerce president Thomas B. Talbert began to petition Washington for the necessary funding.

During the first few days of February 1934, Huston received news from the U.S. Treasury Department regarding the purchase of seven downtown lots at Main Street and Olive Avenue. Additionally, $52,000 was allocated by the Treasury (not the WPA, as is sometimes stated) for the actual construction

of the post office. Huston quickly approved the proposal, and over the next few months the site was inspected and soil tests conducted, and it appeared that work would finally begin on the building for which the city had fought so long to acquire.

However, as the months passed, no work was being done on the site. Finally, by November 1934, the federal government began accepting bids from private contractors for the project. It was also around this time that Huston unveiled the plans for the new post office. The one-and-a-half-story structure, fronting Olive Avenue, was to feature extensive tile work, large windows, a recreation room for employees and a fourteen-inch-thick steel vault.

Despite the promise that work would begin shortly after the December 5 deadline for contractors' applications, questions over the actual ownership of the land plagued the project for another five months. Finally, the city's dream became a tangible reality on May 6, 1935, when mayor Thomas B. Talbert—one of the early proponents of the project—ceremonially turned the first shovel of dirt on the site. From that point on, work progressed steadily toward a December deadline.

December 7, 1935, was selected as the day on which the structure would be dedicated. Local Masonic officers were in charge of laying the cornerstone, and representatives from local churches, schools and other civic groups were present. Prior to the ceremony, the Huntington Beach municipal band led a parade down Main Street, and speakers that day included mayor Talbert, the state postal inspector and other prominent locals. Today, the building still serves as a branch post office, although there has been concern in recent years of closure due to lack of funds.

Although the CWA was one of the shortest-lived New Deal agencies, it had a profound impact on Huntington Beach early on. In early December 1933, J.K. McDonald, a Huntington Beach resident, was elected the chairman of the Orange County Civil Works Administration. Also in the same month, the Huntington Beach Chamber of Commerce began accepting proposals for possible CWA projects within the city. By the end of 1933, McDonald had approved fifty-nine projects within Orange County. Huntington Beach came in second to Santa Ana for the total amount of federal aid received, with over $10,000 initially allotted. Work began in mid-January on a number of new projects, in addition to the continuation of projects begun by the Reconstruction Finance Corporation.

A majority of Huntington Beach's initial CWA money, $8,111.25, was spent on the development of Ocean Front Park—a proposed recreation area located at the base of the pier. In the early months of 1934, a crew of forty

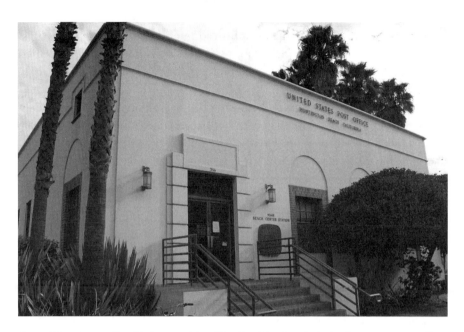

One of Huntington Beach's few surviving New Deal landmarks is the downtown post office, which was built between 1934 and 1935. Contrary to popular belief, the building was built by the U.S. Treasury Department and not the WPA. *Photo taken by the author.*

men was working on the park daily, installing restrooms and beautifying the bluffs and beach. Elsewhere, $1,200.00 was allocated for the painting and refurbishment of city buildings that had been damaged by the March 1933 earthquake (such as city hall, memorial hall and school buildings), and $600.00 was spent on additions to the city's sewer system.

In the following months, several more projects were begun in the city. A storm drain was constructed along Thirteenth Street, and by the end of February, it was announced that the CWA would construct a new baseball field for the Huntington Beach Oilers of the National Night Ball League. Located between Huntington Street, California Street, Knoxville Avenue and Joliet Avenue, bleachers from the old ballpark were moved to the new field. The idea was even proposed for a $500,000 breakwater to be built beyond the end of the pier in 1933, providing Huntington Beach with a pleasure harbor.

The largest project proposed by the city was the construction of a $12,000 bandstand on the beach. Although the development was approved by the city council and an application prepared for the CWA, any hope for such a building was extinguished when the Orange County CWA announced that

all work must end by March 29, 1934; nationwide, the CWA would end two days later. By the time the CWA was finished, it had employed nearly seventy men and spent almost $12,000 in Huntington Beach alone.

In addition to all of the federal aid that Huntington Beach received, the state of California also played a significant role in providing jobs during the Depression. Among the numerous projects funded by the State Emergency Relief Administration was the establishment of four recreational areas in Huntington Beach during the summer of 1935. Approval came from the city council on May 6, along with the allotment of $500 in addition to SERA's financial aid.

The first of these recreational zones extended from the base of the pier to the main lifeguard station, located approximately between Second and Third Streets. This area was equipped with swings, sandboxes and seesaws for young children. In zone number two, from the lifeguard station to First Street, facilities were installed for ping-pong, volleyball, horseshoes, badminton and other games. Continuing south along the beach, zone three ran from First Street to Huntington Beach's Tent City (near Huntington Street). This area was designed for use by basketball, baseball and football leagues. A playground was also installed at Circle Park so that young children did not have to cross the highway.

SERA's recreational zones were only a small part of the continued development of Ocean Front Park. Starting in June 1933, the RFC began supplying money and workers for the beautification of the city's beachfront. A major part of the proposal was an outdoor auditorium, to be called the Newland Bowl, that was to have been located near the base of the pier but was ultimately never built. Also constructed by the RFC were walkways and a rock garden along the coast near the pier. During the winter of 1933–34, Ocean Front Park provided work for forty men.

The RFC's work on Ocean Front Park was transferred to the CWA for a brief period in early 1934, and by June of that year, all operations had been taken over by SERA. Major projects under SERA, in addition to the aforementioned recreational zones, included the construction of a new home for the caretaker of Huntington Beach's Tent City; the terracing and landscaping of the coastal bluff; the building of driveways, bridges and sidewalks; and the installation of retaining walls.

By March 1935, over $20,000 had been put into Ocean Front Park. The 3,700 feet of coastline was considered one of the finest recreation spots in California; however, the city was far from finished with its improvements. On July 25, 1935, plans were unveiled for an auditorium, dance hall and theater

to be constructed at the base of the pier. The building quickly became a hotly contended issue among locals. Some of the city's more traditional citizens were strongly opposed to the idea of promoting dancing; others quickly countered with the projected revenue and tourism.

The $30,000 building was to feature a ballroom on the upper floor and a theater and bandstand on the ground floor. A PWA grant of 45 percent ($13,500) was offered for the recreation building, and the issue was put before the voters. On April 14, 1936, Huntington Beach residents were asked to decide between the proposed pavilion or, as an alternative, a $15,000 bandstand. The pavilion won overwhelmingly with a final vote of 922–510.

The city quickly began planning the new building. The total cost was raised to $42,000, with Huntington Beach providing $25,000. The famed Los Angeles architectural team of Albert R. Walker and Percy A. Eisen, who were responsible for Huntington Beach's city hall and municipal auditorium, were contracted to design the pavilion. The plans were approved by the city council in December 1936, and shortly thereafter, a final application was sent to the WPA for the allocation of funds.

Walker and Eisen's plans were approved by the state the following year, and contracts for the building's construction were accepted in November 1937. Construction on the building, which cost $75,000 when all was said and done, progressed rapidly, and a grand opening ceremony was scheduled for May 26, 1938. Called the Pav-A-Lon (or sometimes the Pavalon), the building was a quintessential example of Streamline Moderne architecture. As was popular at the time, the architecture has a strong nautical influence, as evidenced by the porthole windows and graceful curves of the building. Even the font used for the building's signage is unmistakably Art Deco.

The grand opening ceremony featured many special guests. The Orange County Federal Marching Band performed for those in attendance, and the front door was ceremoniously unlocked with a large gold key by silent picture star Anita Stewart. Also in attendance were local PWA officials who helped facilitate the building's construction, as well as the architects of the building.

Over the course of the next few decades, the Pav-A-Lon became a popular spot for concerts, including James Brown, Ike and Tina Turner and the Beach Boys. However, tragedy struck the building on the evening of October 30, 1966, when faulty electrical wiring sparked a fire in the building that resulted in $31,000 worth of damage and forced four hundred dancers to be evacuated from the ballroom.

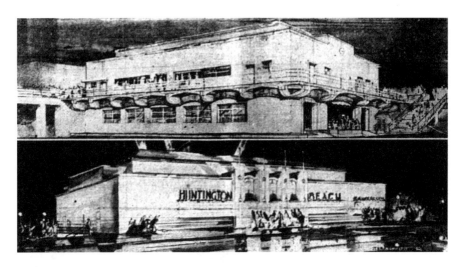

Designed by the famed firm of Walker & Eisen, these extremely rare conceptual drawings of the Pav-A-Lon have not been republished since the mid-1930s. The final design is a textbook example of Streamline Modern architecture.

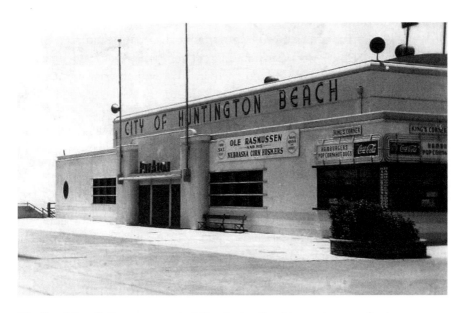

The Pav-A-Lon Ballroom was part of Huntington Beach's massive oceanfront development during the New Deal. The $75,000 building opened in 1938 and was destroyed by a fire in 1966. A restaurant currently sits on the site. *Photo courtesy Orange County Archives.*

What little was left of the building's structure was reconstructed, and two years later, the building reopened as the Fisherman Restaurant (later renamed Maxwell's). However, gone was the Streamline Art Deco design, instead replaced with a much more nondescript building. Maxwell's sign did retain the Art Deco font of its predecessor, however, giving a hint to what was formerly on the site. Maxwell's (and what little remained of the original Pav-A-Lon) were finally demolished in 1994 to make way for yet another new restaurant, which still stands today.

Work continued along the coast until the very end of the New Deal. On June 15, 1938, a $100,000 bond was authorized in order to purchase 1,630 feet of beachfront near the pier. Of the money, $15,000 went toward expanding a trailer park and building restrooms and parking lots. Some even proposed the idea of building a municipal airport along the coast, although the suggestion didn't materialize. Over the course of a few years, the revenue received by the city from Ocean Front Park increased threefold. In the decades that have passed since the New Deal, the developments along the shoreline have changed drastically, and today there is almost no trace of the hundreds of thousands of dollars of work that went into the area.

At the heart of the oceanfront improvements was the Huntington Beach Municipal Pier, which has existed in different iterations since 1903. The first concrete pier was constructed on the site in 1914 and, at the time, was the longest pier of its type in the world. In 1930, the pier was extended from its original length of 1,316 feet to a length of 1,804 feet. Disaster struck on the morning of September 24, 1939, when the only tropical storm to hit California during the twentieth century made landfall in nearby San Pedro, and the last 294 feet of the pier were destroyed (including a café that had been built in 1930).

Workers immediately began repairing the pier, as well as the restaurant that had stood at its end. By August 1940, the pier had been rebuilt to a length of 1,832 feet, and the concrete decking had been completely replaced. The pier that was constructed during the New Deal continued to stand unharmed until 1983, when a storm again washed away the end of the pier; a similar occurrence in 1988 prompted additional rebuilding. Today, the pier attempts to mirror the design of the original pier constructed almost one hundred years ago, although obviously built to much stricter standards.

Westminster

When it was founded in 1870, the city of Westminster was a Presbyterian temperance colony, and settlers soon began arriving from across the country. The first schoolhouse was built in 1872, and the first general store opened two years later. Through the first decades of the twentieth century, Westminster remained a small, quiet city, boasting some of the region's best schools and churches. However, as with many of the surrounding cities, almost all of Westminster's brick buildings were completely destroyed by the 1933 earthquake, leading the city to utilize government aid offered by the New Deal.

In September 1934, it was announced that the firm of Allison & Allison had drafted plans for Westminster Elementary School, although some sources state that H.E. Mackie was the architect for the project. The school, which was later called the Seventeenth Street Hoover School, cost an estimated $30,000 ($15,900 of which came from the PWA). Construction began later that year, and the school was opened in 1935. Located at 7571 Westminster Avenue, the school was demolished in the 1980s to make way for a senior living center.

A misconception exists regarding another building that was located on the elementary school's campus. Several sources cite the school's auditorium as having been built by the WPA in 1940; examination of aerial photographs and maps shows that this was not the case. The auditorium, which was finally demolished in 1996 (ten years after the rest of the school), appears to have been built in the late 1940s and not during the Great Depression years.

Newport Beach

Continuing down the coast, Newport Beach sits between Huntington Beach and Laguna Beach. Due to the area's unique geography, a bay and an underwater canyon provided the perfect location for shipping businesses to thrive as early as the 1870s. The city was incorporated in 1906 and rapidly became a popular tourist destination. Over the course of the next few decades, the city began to flourish, quickly making the need for a better harbor apparent.

In late October 1933, a petition was printed in the *Santa Ana Daily Register* outlining a proposal to completely develop Newport Harbor. The City of

Newport Beach and Orange County had previously funded dredging of the harbor and the diversion of the Santa Ana River dating back to 1916, but throughout the 1920s, public support for a proper harbor was low, and little progress was made. However, popular opinion had swung by the early 1930s, and soon after the harbor improvement plan was unveiled, the Orange County Harbor District was founded.

The original plan printed in the *Santa Ana Daily Register* and presented to the Newport Beach City Council was drafted by Lew H. Wallace, who was responsible for the first highway along Orange County's coast, and R.L. Patterson, the city engineer of Newport Beach. Patterson, the scientific mastermind behind the improvements, envisioned the extension of the harbor's breakwater, a shipping channel dredged to the depth of twenty feet, an anchorage basin dredged to a depth of fifteen feet and the remainder of the harbor dredged to a depth of ten feet.

The total cost of the project was listed as $1,835,441; President Roosevelt's Federal Emergency Relief Act, according to law, would cover 65 percent of the total cost ($1,195,441). However, the government aid would only be provided if the county could raise the remaining $640,000. A vote was set for December 19, 1933, to determine whether the county would issue a bond for this amount.

The Newport Harbor improvements project quickly became a hotly debated topic among Orange County residents. Many people, such as the chairman of the Orange County Harbor Association, A.B. Rousselle, claimed that the harbor would pay for itself almost immediately. He urged voters to look at the project as an "investment, not an expense." In addition to being a pleasure and commercial harbor, it would also serve as a naval auxiliary harbor, bringing in revenue almost immediately. A tax was also proposed on private yachts, wherein $1 would be collected for every $100 value of the vessel. Proponents also pointed out that commerce would develop around the harbor and that yacht owners would move into the county, stimulating the housing industry.

On December 19, after a month and a half of heated debate, the countywide election regarding the project was held. Residents voted overwhelmingly to issue the $640,000 bond, with 17,635 supporting it and only 6,339 opposing it. Work began soon after on dredging the sandbars out of the entire harbor, as well as extending the two jetties leading into the harbor. This massive project—one of the biggest in Southern California during the New Deal—vastly improved sailing conditions in and out of the harbor and helped solidify Newport Beach as one of the premier harbors in

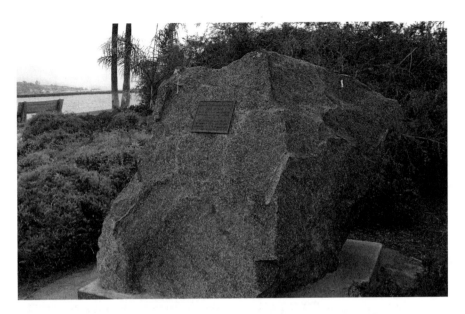

A plaque on the tip of the Balboa Peninsula commemorates improvements that were undertaken at Newport Harbor in the 1930s. The PWA funded a good portion of the $1.8 million project, which made the harbor one of California's finest. *Photo taken by the author.*

the area. The following year, on September 22, 1934, the first barge of rock for the construction of the jetties arrived from Catalina Island. A ceremony was held by local residents and politicians that included breaking a bottle of champagne over the barge.

To commemorate the monumental undertaking, a plaque was placed at the tip of the Balboa Peninsula (only steps away from one of the jetties that was constructed as part of the project). The plaque, which remains today, reads, "Harbor Improvement/1934–1936/This monument erected in appreciation of the services rendered by George A. Rogers on behalf of Newport Bay. Orange County Harbor/May 23rd, 1936." George Rogers was a prominent local resident in the 1930s and one of the leaders of the improvement project from the beginning.

On September 16, 1935, while Newport Beach was in the thick of its harbor improvements, the city council asked city engineer R.L. Patterson to prepare a report on the state of Balboa Island. Patterson's plan, brought before the city council on September 30, called for numerous improvements to the island—namely, the construction of a concrete bulkhead and sidewalk around most of the island, the installation of new light fixtures, the placement of new cast-iron pipe storm drains and the construction of

five wood-and-cement public piers. A small tax was also proposed on some Newport Beach residents to cover some of the cost of the project. Patterson's plan was adopted by Newport Beach's city council on November 4, 1935.

The five public piers were distributed evenly around the island. On the north side of Balboa, piers would be built at Emerald Avenue and Apolena Avenue (later changed to Sapphire Avenue), while the south side would see piers constructed at Coral Avenue and Opal Avenue. On the east side, a pier would be built at Park Avenue. The concrete bulkhead would provide a sturdier seawall for the island, while the sidewalk, piers and light fixtures would promote recreation for visitors and residents.

By November 12, 1935, Newport Beach's city council had filed a grant with the Federal Emergency Administration of Public Works, which would cover 45 percent of the total cost, and the final plan for Balboa Island was adopted by the city on December 2. The federal government, however, wouldn't green-light Newport Beach's proposal until August 20 of the following year, when PWA project "Calif. 1286-R" was authorized. The government agreed to cover 45 percent of the costs (not exceeding $100,035) under the conditions that the project would be started by October 1, 1936, and be completed within one year. The City of Newport Beach accepted the PWA's proposal in a special city council meeting held on August 31, 1936. In 1938, the U.S. Treasury proposed the construction of a $70,000 post office on Balboa Island, although the idea did not ultimately come to fruition. A similar proposition for a Newport Beach station likewise fell through.

Located on the bluffs above Newport Harbor, Newport Harbor Union High School was constructed in 1930, immediately following the Great Depression but before President Roosevelt's New Deal. Ground was broken on June 14 of that year, and three months later, the $410,000 project was completed. Initial enrollment when the school opened on September 22 was only 207 students.

Although not part of the New Deal itself, Newport Harbor High School does feature two works of art that were funded by the Federal Art Project. After the nationwide project's establishment in August 1935, Newport Harbor High School quickly offered $100 for the creation of two large mosaics to decorate the courtyard of Robins Hall, the school's main building. California-based artists (and fiancées) Arthur Ames and Jean Goodwin, who also designed murals in Anaheim, were each commissioned to design and create a mosaic for the school.

Following a requirement that native materials be used if possible, Ames and Goodwin used unglazed tile that was acquired from a local supplier. Their designs also had to be approved by both the high school and FAP

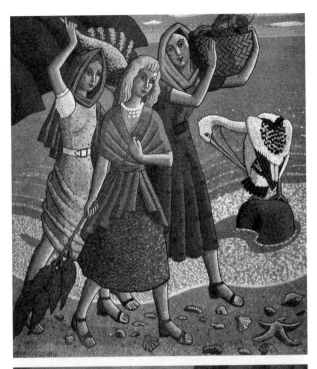

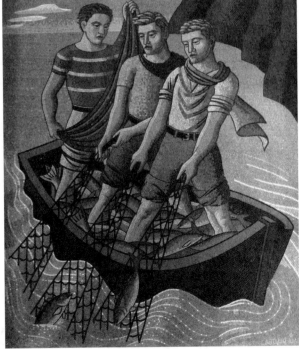

Top: Newport Harbor High School's Robins Hall boasts two mosaics designed by notable Southern California artists Arthur Ames and Jean Goodwin. This one, titled *Three Women Gathering at the Sea Shore*, features Goodwin's name on it.

Bottom: The second of the two mosaics designed as part of the Federal Art Project is Arthur Ames's *Three Fishermen*. The mosaics, which are each seven by nine feet, took more than sixteen months to complete. When Robins Hall was reconstructed in the late 2000s, the mosaics were carefully removed and preserved until placed in their current locations.

representatives. The entire project—designing, constructing and installing the mosaics—took over sixteen months and 5,200 working hours to complete. For most of the time, Ames and Goodwin had three assistants working under them on the mosaics. Amazingly, the final cost of materials came to only $100.95.

Both mosaics are approximately seven by nine feet in size. Jean Goodwin's is titled *Three Women Gathering at the Sea Shore* and features a trio of young women carrying shells, seaweed and lobsters along the shore, while behind them sits a white pelican on a rock. The style of the figures is typical of federally funded public art from this time as its very indicative of the regionalist style. Arthur Ames's mosaic, titled *Three Fishermen*, similarly features three men in a boat hauling in their fishing net.

In the early 2000s, Robins Hall was deemed structurally unsound in the case of an earthquake. Prior to the building's demolition in 2007, the mosaics (and the wall underneath them) were removed and carefully preserved until 2009, when they were installed in the entryway of the reconstructed Robins Hall. The two mosaics currently stand side by side, with a plaque detailing their construction and preservation.

Newport Harbor High School is not the only school in Newport Beach to feature New Deal artwork, however. Newport Beach Grammar School, now called Newport Elementary School, is the oldest school in Newport Beach still in existence, tracing its roots back to 1894. The school moved to its current site in 1912 and was expanded upon in 1922 to take up the entire block bordered by Balboa Boulevard, Thirteenth Street, Fourteenth Street and the beach.

Newport Beach Grammar School was severely damaged by the March 10, 1933 Long Beach earthquake, which rendered the 1922 structure unsafe and unusable. What was left standing was soon demolished, and plans were drawn up for a new school. The architect hired for the project was D.B. Kirby, and the current structure opened its doors on December 17, 1935. The architecture of the building is quite unique; it features many characteristics of the WPA Moderne style while also incorporating a maritime theme due to its proximity to the ocean. A flagpole in front of the school was erected by the Newport Harbor American Legion Post 291 in 1936.

The building's most notable features, however, are two large oil-on-canvas murals that hang in the school's main hallway. Painted by San Diego–based artist Jaine Ahring in 1937, they were commissioned for the school as part of the FAP. Given the scarcity of New Deal public art in Orange County, Ahring's paintings are quite remarkable. The first depicts scenes from Lewis Carroll's *Alice in Wonderland*, including Alice carrying a flamingo, the Mad

This photograph shows Newport Beach Grammar School (now Newport Elementary School) shortly after its completion in 1935. The building was designed by architect D.B. Kirby. Today, the school appears much as it did when it was first opened. *Photo courtesy Orange County Archives.*

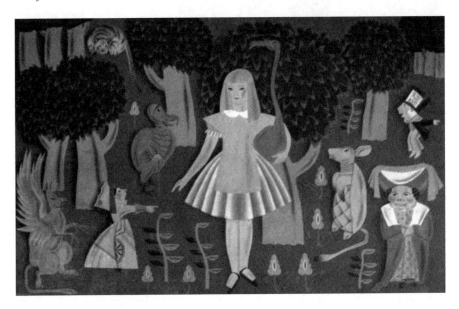

One of two oil-on-canvas murals painted by FAP artist Jaine Ahring for Newport Beach Grammar School. This one depicts scenes from Lewis Carroll's novel *Alice in Wonderland*. Today, the murals are preserved under glass.

The other of Jaine Ahring's two murals at Newport Beach Elementary School is *Mother Goose*, which depicts characters from the most popular nursery rhymes. Both of Ahring's murals were funded by the Federal Art Project.

Hatter, the Cheshire Cat, the Dodo, the Duchess, the Gryphon, the Mock Turtle and the Queen of Hearts. All of Ahring's figures are heavily inspired by John Tenniel's original illustrations for Carroll's book. The second painting in the school is titled *Mother Goose* and features an array of characters from her best-loved stories, including Old King Cole, the cow jumping over the moon, the cat and the fiddle, Little Bo Peep, Little Miss Muffet, Jack and Jill and Mary, Mary, Quite Contrary. Both of these paintings are currently preserved under glass, ensuring their enjoyment for future generations of schoolchildren.

COSTA MESA

Although Costa Mesa is currently the eighth-largest city in Orange County, during the 1930s, it was a small, unincorporated community that was only just beginning to grow. As with many Southern California cities, much of that progress was hindered by the 1933 Long Beach earthquake, which destroyed much of what little industry and infrastructure Costa Mesa had.

Costa Mesa Grammar School, located on the northwest corner of the intersection of Newport Boulevard and Nineteenth Street (1901 Newport

The firm of Perrine & Mackie designed Costa Mesa's elementary school in 1935 after the previous structure had been destroyed by the 1933 earthquake. The Spanish Colonial Revival building was demolished around 1980. *Photo courtesy Orange County Archives.*

Boulevard), was opened in 1923—the same year that Costa Mesa got its first sidewalks and first local newspaper. Almost completely destroyed by the 1933 earthquake, the city opted to reconstruct the school in 1935, incorporating some of the earlier buildings. The architects for the project were the Los Angeles firm of Perrine & Mackie, who also designed schools throughout California. Their design was a very subtle Spanish Colonial Revival style.

Through a combination of federal funds and local bonds, the school cost approximately $70,000 to build. It was also around this time that the school changed its name to the Main School, due to the construction of another elementary school several blocks away. After being renamed several more times, the school finally closed its doors in 1980, and the site is now a retail complex.

The New Deal years also saw the establishment of Costa Mesa's first permanent fire station. Established in 1926, the Costa Mesa Fire Department began construction of its new headquarters, located at 121 Rochester Street, in the summer of 1938. Costing $10,000, the two-story structure was dedicated on November 18 immediately before the annual Fireman's Ball. The Rochester Street Fire Station was the only station in Costa Mesa until 1958; however, by 1979, the station was closed, and it was demolished two years later to make room for a parking lot.

CHAPTER 3

Northern Orange County

Cypress

Located in northwestern Orange County, the city of Cypress has gone by several names over the course of its history. The original name was Waterville, due to local wells, and the city was incorporated in 1956 as Dairy City. The following year, the name was changed to Cypress, after the local elementary school, which was surrounded by cypress trees to protect it from the wind. The elementary school, which was originally constructed in 1895, was also the recipient of government aid during the New Deal.

Located at 5202 Lincoln Avenue, what was formerly Cypress School is now the Cypress Calvary Chapel School. In 1936, a total of $58,000 was spent on the school on a building designed by architects W. Horace Austin and H.C. Wildman. Their structure included six classrooms and a five-hundred-person auditorium; today, the school uses the auditorium as its chapel. At the time it was constructed, Cypress School was the only school in the Cypress district.

Cypress Elementary School was expanded in 1936 using PWA funds. Currently the Cypress Cavalry Chapel School, the former public school's auditorium now serves as a chapel. The 1936 addition was designed by W. Horace Austin and H.C. Wildman. *Photo taken by the author.*

BUENA PARK

Located immediately north of Cypress is Buena Park, which was incorporated only a few years earlier in 1953 (although the name dates back to 1887). Although not very large in population, Buena Park suffered severe damage in the 1933 earthquake, which destroyed every brick building in the city. In the aftermath of the earthquake, Buena Park received $9,000 in federal aid for the rebuilding of local elementary schools.

During this time, Buena Park had two elementary schools. The first, located at the northwest corner of Melrose Street and Grand Avenue (now Beach Boulevard), was built in 1897. In 1926, the school changed its name to the Grand Avenue School, as a new school was being constructed at Fourth Street and Stanton Avenue. Opened in 1927, this school was named after Charles Lindbergh, who had completed his transatlantic flight earlier that year. Which of these two schools received federal aid

or whether they split the money is currently unknown. Today, neither school is standing.

Nearby the Grand Avenue School was the original Buena Park library, first constructed in 1919. At the height of the Great Depression, in 1934, a $5,908 addition was added to the library, presumably funded by a PWA grant. Located at Beach Boulevard and Pinchot Court, this library proved too small for the growing community of Buena Park in the 1960s, and a larger facility was constructed on La Palma Avenue. Today, the site of the former library is a parking lot.

FULLERTON

With a population of just more than ten thousand in 1930, Fullerton was one of the largest cities in Orange County at the time of the Great Depression. As would be expected in a city so large, relief projects were numerous. In fact, although it is impossible to calculate exact dollar amounts, it is probable that Fullerton received more aid than any other Orange County city. What is also unique about Fullerton is the fact that nearly all of its New Deal buildings are still standing and preserved as historic landmarks.

A large part of New Deal spending in Fullerton was on the city's elementary schools, which all required maintenance following the 1933 earthquake. Engineers recommended a building program that totaled $325,000; as part of this plan, four of Fullerton's elementary schools would be rehabilitated, and the city's junior high school would be entirely reconstructed.

One such school was the Ford Avenue School, located at 301 North Ford Avenue. Originally built in 1920 and expanded in 1928, the school underwent $56,000 worth of renovations following the earthquake. Due to a lack of enrollment, the school was forced to close its doors in 1979 and was demolished several years later.

Another of Fullerton's schools to receive federal aid in the 1930s was the Maple Street School, located at 244 East Valencia Drive. In mid-1934, the Fullerton Elementary School Board estimated that $25,000 was needed to retrofit the Maple Street School following the 1933 earthquake. A year later, in November 1935, architect Everett E. Parks (along with consulting architects Myron Hunt and H.C. Chambers) were finalizing plans for a 2,400-square-foot addition, in addition to the refurbishments initially planned.

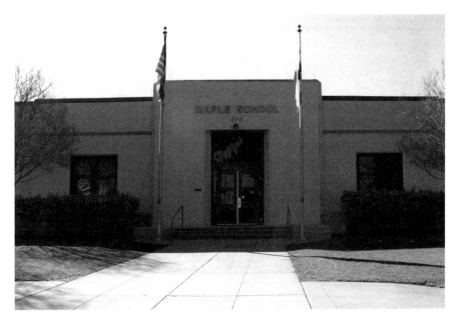

Fullerton's Maple Street Elementary School represents one of the city's less well-known New Deal projects. Funded in part by the PWA, it maintains a high degree of its architectural integrity.

Opened in 1936 for a final cost of $45,000 (partially funded by the PWA), the Maple School is one of Fullerton's more subdued and simple examples of Art Deco architecture. Although additions have been made to the school grounds, the building's façade appears mostly unchanged from when it was constructed and is an oft-forgotten piece of Fullerton's vast array of New Deal projects.

Farther away, on the western outskirts of Fullerton, was the Valencia School (at approximately 2355 West Valencia Drive). As part of the same overarching school reconstruction plan, this small school was allocated $12,838 in the aftermath of the earthquake. In the 1950s, the school moved to a new location a block away; however, based on aerial photographs, it appears that the original brick school building is now part of the Fullerton Seventh Day Adventist Church, retaining much of its architectural integrity.

Nearer to downtown, two different schools once shared the same property. Both the Wilshire Junior High School and the Chapman School were located along Lemon Street between Chapman Avenue and Wilshire Avenue. The Chapman School, located on the northwest part of the lot, was originally constructed in 1921; the earthquake, however, damaged the school's main

The New Deal in Orange County, California

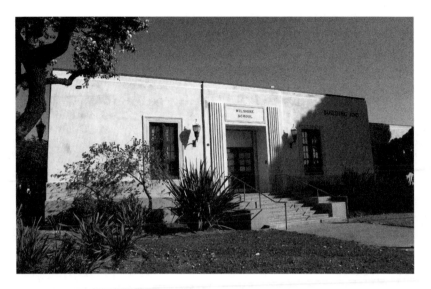

One of several schools in Fullerton that were either constructed or reconstructed in the mid-1930s, Wilshire Junior High School features a very subtle Art Deco design. Three of the school's buildings are still standing and currently house the School for Continuing Education. *Photo taken by the author.*

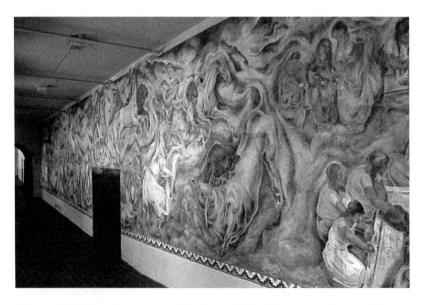

Fullerton High School features one of Southern California's largest works of public art from the New Deal. Charles Kassler Jr.'s *Pastoral California* was painted over soon after it was completed due to its controversial style. In 1997, however, the fresco was completely refurbished and can once again be enjoyed by the public. *Photo taken by the author.*

entrance beyond repair. Various repairs and additions totaling $41,000 were carried out during the 1930s.

On the southwest part of the lot was Wilshire Junior High School, which was deemed too badly damaged to be repaired after the quake. Beginning in 1934, the school was entirely reconstructed for a cost of approximately $170,000 (partially using PWA funds). It opened in 1936. Three of these original buildings, including the auditorium, are still standing today. Like the Maple School, these buildings are not as striking as some of Fullerton's other landmarks from this era, but they are no less important in documenting the role the New Deal played in the city.

The school's design is very mildly Art Deco and, like several other buildings in Orange County, is best described by the term "Greco Deco"—architecture that simultaneously blends the modernity of the 1930s with classic Greek and Egyptian motifs. After the junior high school closed in the 1980s, the buildings were acquired and refurbished by the North Orange County Community College District. Today, the school serves as the School of Continuing Education. With the exception of several windows that have been filled due to noise, the school maintains much of its architectural integrity.

Across the street from Wilshire School is the Louis E. Plummer Auditorium, part of Fullerton High School. Constructed in 1930 for a cost of $295,500, the auditorium is a very impressive example of Spanish Colonial Revival architecture. Although the auditorium itself was not constructed during the New Deal, it does feature a giant fresco painted by Charles Kassler Jr. under the Public Works of Art Project in 1934 (and not under the WPA, as is commonly stated). Spanning seventy-five feet by fifteen feet, the mural is unmatched in its size and scope. In fact, this painting and another of Kassler's works (*Bison Hunt*, located at the Los Angeles Public Library) are the two largest frescoes commissioned during the New Deal. Titled *Pastoral California*, the painting (which is unique in that it was done in a true fresco style and not simply painted onto the wall) portrays life in California under Spanish and Mexican rule. Depicted in the painting are landmarks such as Mission San Juan Capistrano and local heroes such as Pio Pico and Jose Antonio Yorba.

However, as impressive as the mural may have been, not everyone was a fan of it. Only five years after it was completed, the high school trustees called the mural "vulgar" and "inappropriate" due to its stylized forms and bright colors and ordered that it be painted over because it did not match the architecture of the school. Because the painting was done as a fresco, though, the entire piece remained very well preserved under the new coat

of paint. After fifty-six years of being covered, a widespread community effort in 1997 led to the complete restoration of Kassler's mural, which now once again graces the west wall of the auditorium. *Pastoral California* is undoubtedly the most impressive piece of New Deal artwork in the county, if only for its shear physical size and far-reaching subject matter.

At the same time that Kassler was painting his mural, SERA and the PWA provided the school with funding for new bleachers and locker rooms. The new stadium would have been located where the baseball fields are today. Called the "best equipped and the best lighted in the country" and constructed at a cost of $90,000, this stadium was dedicated on November 22 and 23, 1934, at a ceremony with five thousand people in attendance. There is also evidence to suggest that the WPA spent $75,000 on a new classroom building on Fullerton High School's campus.

Higher education was also affected by the New Deal in Fullerton. Founded in 1913, Fullerton College (formerly known as Fullerton Junior College) is the oldest continuously operating community college in America. In 1907, the early days of California's Progressive Era, a law was passed allowing high schools to offer post-graduation programs to students who could not attend a four-year college. Beginning in 1910, junior colleges were opened in Fresno, Santa Barbara, Los Angeles, Hollywood, Bakersfield and Fullerton. While many of these schools still exist in some form or another, Fullerton has been operating as the same institution since it was founded.

For the first two decades of its existence, Fullerton Junior College shared Fullerton Union High School's campus, even being run by the same administration until 1922. Louis E. Plummer, superintendent of both the high school and the college, realized the need for a separate campus. A sixteen-acre lot immediately east of the high school, covered in walnut groves, was purchased. Initially, faculty and local residents began raising money for the new college; however, as early as 1934, federal funding was requested, and the CWA provided $41,000 to clear the land of walnut groves and prepare for construction. Three hundred laborers were initially given jobs on the project.

In 1935, Fullerton architect Harry K. Vaughn teamed up with landscape architect Ralph D. Cornell to create a general plan for the new Fullerton Junior College campus. Modeled after Thomas Jefferson's layout of the University of Virginia, Vaughn sought not just to design the buildings but also to create a cohesive campus that included parks, walkways and courtyards. In all, Vaughn designed twelve buildings, all of which the school board hoped would be built using federal funding over the next decade.

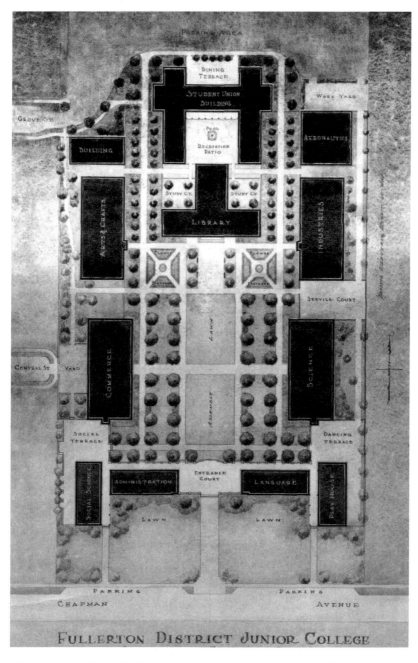

This map shows Harry K. Vaughn's original plan for the campus of Fullerton Junior College. Inspired by the University of Virginia, many of the buildings were left unrealized due to the start of World War II.

Although Harry Vaughn's campus layout debuted in the November 1936 issue of *California Arts and Architecture* magazine, students and staff had gathered the previous March for the groundbreaking ceremony of the new campus. One thousand students, as well as the marching band, marched from Fullerton Union High School to the new college on the morning of March 12, 1936. The first building that work was begun on was the Commerce Building. Costing $148,777, 45 percent of which was provided by the PWA, the Commerce Building features impressive Spanish Revival architecture by Vaughn that would be replicated in all later buildings on campus.

As the Commerce Building was being completed in 1937, plans were being made for the next building in Vaughn's master plan. In April of that year, construction began on the Administration and Social Science Building, which was opened on February 5, 1938. As was the case with the Commerce Building, the PWA supplied 45 percent of the building's $163,633 cost (with the rest being raised by the city). All subsequent buildings on Fullerton Junior College's campus would be funded by the WPA, as opposed to the PWA.

The Administration and Social Science Building housed the college's administrative offices, as well as six classrooms and a student lounge. Like the first building, it featured red tile roofs and Spanish-influenced details. Between the two buildings, Vaughn designed pathways and courtyards to unify the campus. Also begun in 1937 was the Technical Trades Building, which was designed to house $40,000 worth of machinery. Costing $224,321, Vaughn's third building was the first to be funded by the WPA.

As the 1930s came to a close, construction began to slow at the college. A greenhouse was constructed in 1937 both for horticultural classes and to raise plants to place around the campus. Additionally, the WPA gave $47,793 for landscaping and the installation of a sunken garden, helping to beautify Vaughn's already impressive campus. The last buildings to be completed by the WPA around 1939 or 1940 were the Student Union ($60,454) and the Shop Building ($76,605), the latter of which has since been demolished.

During the New Deal era, only about half of Vaughn's original general plan for Fullerton Junior College was ever realized, as there was no longer any funding for public works after the United States entered World War II. However, a second wave of construction in the 1950s (as well as more recent projects) helped to complete the campus that he originally envisioned. Today, the four buildings that still stand offer one of the best collections of New Deal buildings in the area, and their cohesive designs make Fullerton College's campus a true architectural gem from this time period.

In the midst of Fullerton's numerous other WPA projects, talk began in the late 1930s about the construction of a new library. Fullerton's first permanent library building was an Andrew Carnegie–funded library constructed in 1907. Years of wear (and the 1933 earthquake) took their toll on the Mission Revival–style building, and by the end of the 1930s, the Fullerton Planning Comission was tasked with acquiring additional land and funding a new structure. In mid-1938, the entire planning commission was dismissed due to its lack of action with regards to the new library; a new staff was brought in, and work began to progress rapidly.

By 1941, WPA funding and workers had been acquired, and the Carnegie library was demolished to make way for the new structure. The new library, which would also occupy land to the north of the original library, was constructed at a cost of $150,000. By the end of 1941, WPA crews were putting the finishing touches on the building, which was completed on Christmas Eve 1941. A three-day grand opening ceremony was held the following January.

Again, Fullerton-based architect Harry Vaughn was selected to design the WPA library. Using a style that was contemporaneously described as "Mexican" architecture, he drew from such influences as Spanish Revival, Moorish and Aztec structures. True to its influences, the building features deep-set doors and windows, patios and a red tile roof. Details such as a small copper cupola, copper gutters, stained-glass windows and molding around the entrance led this library to be called "one of the most beautiful in Southern California" by contemporary reporters.

Designed to house 135,000 books (three times the previous number), the new library was a big deal for the growing community. The three-day celebration of its construction culminated on January 22, 1942, when the building was dedicated in an impressive ceremony. Speeches were given by H. Russell Amory, Southern California director of the WPA, and Dr. Rufus B. Von KleinSmid, president of the University of Southern California, and an American flag was presented by Fullerton's American Legion post.

Vaughn's 1941 structure, which stands at 301 North Pomona Avenue, served as the city's public library until 1973, when the current library was built several blocks away. In April 1974, the Fullerton Museum Association took over the WPA library building, and today the Fullerton Museum Center occupies the site. On the outside of the building, a plaque reads, "BUILT BY UNITED STATES WORK PROJECTS ADMINISTRATION 1941."

The first federally owned building in Fullerton was the post office at 202 East Commonwealth Avenue, which was constructed in 1939. The first

The New Deal in Orange County, California

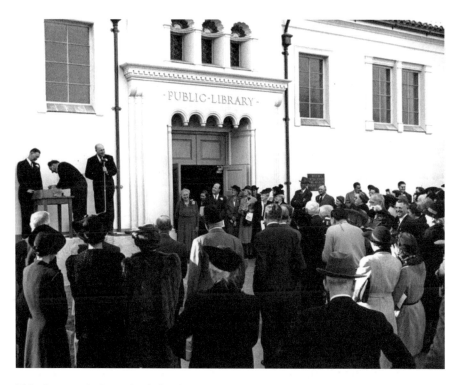

This photograph shows the dedication ceremony of the Fullerton Public Library, which was constructed in 1941 by the WPA. Like Fullerton Junior College, it was designed by Harry K. Vaughn. Since 1974, the building has housed the Fullerton Museum.

In addition to the Public Works of Art Project and the Federal Art Project, the U.S. Treasury Section of Painting and Sculpture also created New Deal public art (specifically in post offices). Orange County's sole example is Fullerton Post Office's 1942 mural, *Orange Pickers*, painted by Paul Julian. *Photo courtesy Smithsonian Institution.*

attempts for Fullerton to receive its first standalone post office, however, date back to at least 1931, when the U.S. Treasury Department granted funds to the city. Plans fell through the following year, and by 1933, local residents were disgruntled that other local cities (such as Orange and Anaheim) were having such ease in acquiring new post offices. One newspaper report stated, "Fullerton is one of the few cities of its size in California that has no post office building."

In 1936, the local chamber of commerce teamed up with congressman Samuel L. Collins to petition the federal government for funding, and on September 10, 1937, it was announced that Fullerton would finally have its own post office. Two properties were purchased at the corner of Commonwealth Avenue and Pomona Avenue, and demolition began in 1938. That same year, the Office of the Supervising Architect (headed by Louis A. Simon), who was in charge of designing federal buildings at this time, began drafting plans for the new structure.

Although construction cost only $56,000, once the building was furnished and outfitted with equipment, the cost totaled $91,000. Many sources incorrectly state that this building was a WPA project; however, as was the case in Huntington Beach, construction of post offices is actually funded by the Department of the Treasury. Construction began on April 3, 1939, and for the next seven months, jobs were provided for forty local men. Local Masons laid the cornerstone on June 3, 1939, and the completed structure was dedicated on October 28 (although it would not open until November 20). The Spanish Colonial Revival building, which blends seamlessly into the architecture of the surrounding buildings, served as the city's only post office until 1962.

Three years after the post office was completed, the Treasury Department Section of Fine Arts commissioned a young artist by the name of Paul Julian to paint a mural inside the building. Julian painted the mural at the Federal Arts Project studio in Los Angeles, and it was installed in 1942. The work, aptly titled *Orange Pickers*, depicts two men and two women picking oranges—something that would have been a common sight in the 1930s and '40s. An oil derrick and airfield are also shown in the painting, representing Fullerton's other major industries at this time.

Like Kassler's mural on Plummer Auditorium, this mural is best described as an example of regionalism, a style that was extremely popular during the Great Depression. Paul Julian went on to have a very successful career at the Warner Bros. studios animating *Looney Tunes* shorts; however, he is perhaps best remembered for providing the Road Runner's iconic "beep, beep"

sound. Today, *Orange Pickers* helps to distinguish the Fullerton Post Office as an integral piece of New Deal architecture in Orange County.

Although Fullerton received such a vast amount of aid during the New Deal, its city hall is arguably the most significant building in the entire city. Located at 237 West Commonwealth Avenue, the impressive Spanish Colonial Revival building is now home to Fullerton's police department. Taking nearly three years to complete and costing over $130,000, it is one of the most striking examples of New Deal architecture located anywhere in the county. It also has one of the longest histories of any of the county's public works from the 1930s.

Plans for construction of a dedicated city hall in Fullerton date back to 1910, just six years after the city was founded. For over two decades, residents fought over where to construct the building; on multiple occasions, plots of land were purchased, but in each case the proposal was defeated by the public. This continued until mid-1933, when President Roosevelt's National Industrial Recovery Act provided the perfect opportunity for the city to finally construct infrastructure.

On July 18, 1933, only a month after the PWA had been established, Fullerton hired architect George Stanley Wilson, best known for his work on Riverside's Mission Inn, to design the new civic center. The building was initially planned to be constructed in Commonwealth (now Amerige) Park, but public outrage forced the city to reconsider. Although the PWA (and, after 1935, the WPA) had approved funding, all work on the building was halted when a decision on its site could not be reached. On December 8, 1936, a measure was passed by a margin of ninety-four votes banning construction in the park, forcing the city to look elsewhere.

After the WPA granted the city an extension for its funding, local lawmakers began looking for alternate locations. Finally, a site was selected on the northeast corner of Commonwealth Avenue and Highland Avenue, of which voters overwhelmingly approved by a vote of almost two to one. The lots were purchased by the city for $25,050, and construction began on September 28, 1939. Wilson's design was especially opulent by Great Depression standards. Rising one and a half stories and featuring a striking three-story tower, the building also features a full basement and sunken patio.

Construction of the new city hall took almost three years to complete. City officials moved into the building in early 1942, and a large dedication ceremony was held from July 20 to July 25 of that year (despite this, a plaque on the building reads, "BUILT BY UNITED STATES WORK PROJECTS ADMINISTRATION 1940"). By the time it opened, the United States had

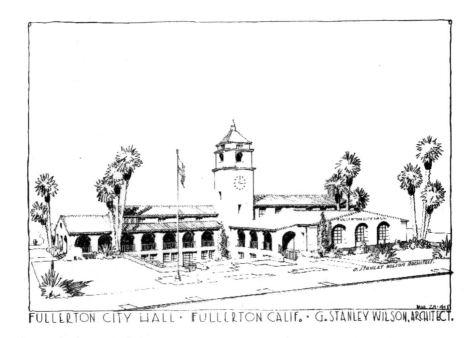

Fullerton's city hall is one of Orange County's most impressive New Deal buildings. Designed by architect G. Stanley Wilson, work began on the building in 1939 and took almost three years to complete. This rendering, done by the architect himself, shows the building much as it appears today (although it is now used as the police department headquarters).

already entered World War II, and the basement was serving as the city's civil defense headquarters. By the 1960s, the city had already outgrown the structure, and a new city hall was built across the street in 1963. Since then, the WPA building has served as the police headquarters for Fullerton.

One of the hall's most distinctive features is its extensive tile work. All of the tiles on the building were produced by Gladding, McBean and Company, which was founded in 1875. A large number of red terra-cotta tiles line walkways, stairs, doors, planters and walls, while many decorative tiles can also be found on and around the buildings. The glazed ceramic tiles, which are mainly blue, yellow and white, perfectly complement the structure's Spanish architecture, while their geometric designs pay homage to the Art Deco craze of the era. Other decorative elements include large amounts of wrought iron that are original to the building.

Most cities would be happy with one piece of New Deal public artwork; Fullerton, however, is the only city in Orange County that can claim three. In addition to the Plummer Auditorium and post office murals, there is

The New Deal in Orange County, California

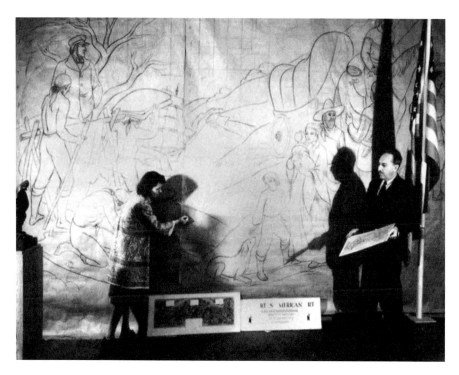

In 1941, artist Helen Lundeberg was commissioned by the FAP to paint a large mural in Fullerton's city hall. After being covered for nearly three decades, it was once again unveiled to the public in 1993.

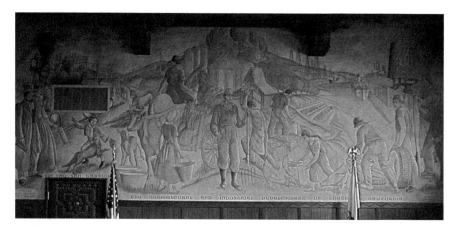

One of Orange County's most impressive pieces of New Deal public art is Helen Lundeberg's *History of California*, located in the Fullerton Police Department headquarters (formerly Fullerton City Hall). The mural, which covers three walls of a room, depicts the history of the state from the landing of Cabrillo through the birth of the movie industry.

also a three-part mural that the WPA's Federal Art Project commissioned artist Helen Lundeberg to paint in 1941. Lundeberg was one of Southern California's most prolific painters during the mid-twentieth century; in addition to the numerous projects she did for the WPA, she is also considered to be one of the founders of the post-surrealism art movement.

Lundeberg's mural was titled *The History of Southern California* and, living up to its name, depicts everything from the landing of Juan Rodriguez Cabrillo in San Diego in 1542 to the birth of the aircraft and movie industries in Los Angeles in roughly chronological order. Like Fullerton's other two murals from this time, it is regionalist in style, although with much more subdued colors. The entire piece covers nine hundred square feet, making it only slightly smaller than Kassler's fresco at the high school. When it was originally painted in 1942, the room in which it was installed was used as the city council chambers.

The first portion of the mural, on the east wall of the room, shows the earliest days of Southern California. Cabrillo's landing is depicted, as are Father Junipero Serra and his missions and the ranchos that were prevalent during California's Mexican period (1822–46). The second segment, on the south wall, continues the story of Southern California, showing many iconic figures who impacted the landscape. Sailors are shown near Dana Point, as are settlers in the Sierra Nevada Mountains. Next, scenes from the Mexican-American War are shown, including famous Americans Kit Carson, General Stephen Watts Kearney and Commodore Robert F. Stockton. Andrés Pico and John C. Fremont are also shown signing the Treaty of Cahuenga, which ended the war. Lastly in the second panel is gold mining in the 1840s.

The last of the three portions of the mural portrays the more recent history of Southern California. The development of the railroads in the region, as well as the spread of the agricultural and dairy industries, are all depicted. The most recent part of the mural shows the growth of the oil, aircraft and motion picture industries at the start of the twentieth century. As well received as the mural may have been by the public, once the police department took over the building in the 1960s, a false ceiling was installed and part of the mural was painted over. It remained covered for nearly three decades, but in 1992–93, an $80,000 movement was undertaken to restore Lundeberg's work. It was unveiled on May 3, 1993, and can once again be enjoyed by the public.

In addition to the many buildings constructed in Fullerton, several local parks also received government aid. At thirty-five acres, Hillcrest Park is not only one of the city of Fullerton's largest parks but also one of the most

historically significant in the region. Originally purchased by the city in 1920 for $67,300, the park spent the early part of its history as a barren automobile camping side; however, a widespread effort in the 1920s resulted in many of the park's trees being planted. It would take the New Deal's widespread efforts, though, for the park to become the oasis that it is today. The amount of work done in Hillcrest Park during the New Deal is staggering, with projects being funded and constructed by the CWA, WPA, RFC and SERA.

Although none of the park's historic buildings were constructed by the New Deal, much of Hillcrest Park's landscaping was done during this era. One of the earliest relief projects in the park was the excavation of the "Big Bowl." Reconstruction Finance Corporation workers in 1933 turned a natural indention in the landscape into a large grassy amphitheater, which is still used for events today. The park's pine forest was also replanted with eucalyptus trees around this same time.

Perhaps the most iconic feature of Hillcrest Park is the Depression-era stonework that runs throughout the park. Although other local parks, such as nearby Amerige Park, Orange's Hart Park and San Juan Capistrano's Stone Field, feature stone structures from this era, none come close to the sheer number of projects at Hillcrest. The style of these stone structures is the distinctive rustic style of the 1930s that is seen in so many government projects from the decade. Given the amount of stonework in the park (and the consistency in style), it can be difficult to determine exactly which government agency constructed each feature; therefore, it is best to take the park's New Deal stonework in its totality instead of looking at each structure in isolation.

Beginning in the northeastern-most part of the park is the Hillcrest Park reservoir, for which the land was originally purchased. The entrance off of Lemon Avenue is marked by two seven-foot stone pilasters built in 1936. Although the pump building that the CWA originally constructed in 1934 was replaced in 1988, there is still a stone retaining wall and staircase near the reservoir that were built by SERA that same year.

Nearby is the park's upper picnic area, which features stone picnic tables, a drinking fountain, barbecue grill and other structures built by the WPA in 1937. When the upper picnic area became too crowded in the 1930s, the nearby sycamore grove was converted into the lower picnic area, featuring similar WPA- and SERA-built facilities. A staircase from this era connects the two locations.

In the southeastern part of the park, stone pilasters line some of the park's roads, which were originally graded in the 1920s. Also nearby is the

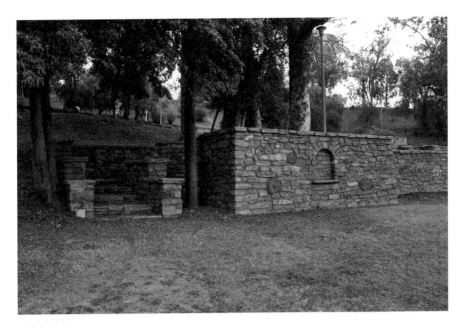

Fullerton's Hillcrest Park features a large amount of infrastructure put into place by a number of different New Deal agencies. The flagstone walls and staircase seen here are representative of much of the park; nearby Amerige Park features similar flagstone pilasters constructed around the same time. *Photo taken by the author.*

American Legion Patriotic Hall, constructed in 1932. Although the building itself was not a product of the New Deal, SERA workers added the flagstone terrace and planters in front of the hall. Along with the rest of the stonework in the park, the raw material was quarried fairly locally in Pomona and the Imperial Valley.

Hillcrest Park's most distinctive feature, however, is the large terrace facing Harbor Boulevard, which formerly featured an impressive electric fountain that was a popular local attraction. Designed by assistant city engineer John W. King, the fountain's central jet would spray water twenty-eight feet into the air. Sixty-five additional jets and twenty-two colored light projectors made the fountain one of the most impressive sites in the county. Each day, it was turned on at 2:00 p.m., while the light show operated from 6:00 p.m. to 10:00 p.m. Every six minutes, the fountain would go through sixty-two color, light and water changes. When WPA laborers constructed the fountain in 1936, it cost $20,000.

Although the fountain operated for decades, upkeep costs in the 1970s proved too prohibitive. Today, although the large base of the fountain is still standing, it is instead used as a planter. Surrounding the base are WPA-

constructed walls, pathways, benches and staircases. Between 1935 and 1936, the WPA also added the park's Great Lawn in front of the fountain. Slightly to the north is a now-drained lily pond, which features a flagstone bridge constructed by SERA in 1934.

Today, Hillcrest Park represents the finest example of a WPA-era park in Orange County. While many parks in the region have several structures built in the 1930s rustic style, none can claim the sheer extent of projects that Hillcrest Park has. Additionally, the fact that no fewer than four individual governmental relief agencies contributed to its construction makes Hillcrest Park unique in Orange County. Fortunately, the park has enjoyed federal historic recognition since 2004, so the Depression-era structures will continue to stand for generations to come.

Amerige Park (called Commonwealth Park until 1937), which was almost home to Fullerton's city hall in the early 1930s, was also developed under the New Deal. A wooden grandstand was built at the baseball field in the early months of 1934, presumably using funds from either the CWA or PWA. What was left of the grandstand constructed during this era was destroyed by a fire in the 1980s, and a new structure was built in its place.

Another piece of New Deal history still stands in Amerige Park, however. As the grandstand was being built, large pilasters made of mortar and flagstone (similar to the flagstone structures at Hillcrest Park) were built along the outfield of the baseball stadium. When the park was renovated in the late 1980s, the pilasters were moved to their present locations, where they continue to stand eighty years after they were first built.

La Habra

Located along Orange County's northern and western borders with Los Angeles County, La Habra was incorporated in 1925, when the city had three thousand people. Known largely for its avocado crops, La Habra remained fairly small during the 1920s and 1930s. Despite this, the city did experience some developments during the Great Depression, particularly with regard to the town's original civic center.

Details are hard to come by regarding many of the buildings constructed during this era, although La Habra appears to have received a sizable amount of governmental aid. In 1930, three years before President Roosevelt's

This photograph shows La Habra's former library (constructed by the WPA), as well as a veteran's hall constructed several years earlier. Today, the library serves as the city's history museum. La Habra was also formerly home to a city hall constructed during the New Deal. *Photo taken by the author.*

New Deal was enacted, the city built its first fire station near La Habra Boulevard and Main Street. A few years later, in November 1934, the city added a Veterans' Memorial Hall to the civic complex, at a cost of $8,000. As soon as the hall was dedicated, plans were designed for a new city hall by local architect Marc Soderberg. SERA labor and funding was used, and La Habra's first city hall opened in 1935. The structure was estimated to cost $15,000 and, like the preexisting buildings, was designed in a Spanish Colonial Revival style.

Over the next few years, several more buildings were added to the civic center, including a police station, post office and library. The library, located immediately west of the Memorial Hall, now serves as the La Habra Historical Museum. Although the museum claims the building was constructed between 1935 and 1937 using WPA funds, it is unclear exactly which New Deal agency actually financed the building. A $70,000 post office was also proposed for the civic center, although it was ultimately never constructed.

By the 1960s, La Habra had outgrown the structures built during the 1930s, and the city began looking to expand. A new library was constructed

in the same complex in 1966, and in 1969, a new city hall was built on the site of the 1935 building. Today, both the original library building and Memorial Hall are still standing at the heart of the civic centers, serving as reminders of the city's original infrastructure built during the New Deal.

PLACENTIA

When Placentia was incorporated in 1926, the city had only five hundred residents; however, the vast amount of agriculture in the region brought a steady supply of new residents over the years. The need for a city hall in Placentia goes all the way back to December 1933, when the city council realized its importance but determined that the estimated cost of $15,000 was too great for it to afford. Despite a PWA offer of $17,000 in January 1935, the issue would not come to fruition until August 2, 1938, when the city made three proposals for public works projects: the construction of a city hall, the installation of a municipal water system and the development of a city park. The park project was ultimately dropped, but legislation progressed on both the city hall and water system.

On September 23, 1938, the decision of whether to issue bonds to fund a new city hall and waterworks system was put up to the voters. The installation of water pipelines, fire hydrants and pumping plants, at a cost to the city of $60,000, passed by a margin of 221–101. Likewise, the issuance of bonds totaling $10,000 for the construction of a city hall (including a jail and fire department facilities) passed, with 220 supporting and 97 opposing.

Placentia authorized $70,000 worth of bonds on June 30, 1939, and work progressed rapidly. By August, W. Horace Austin and Harold C. Wildman of Santa Ana were selected as the architects of the new city hall. Three months later, the city filed WPA application No. 1104-4162 to secure additional funding for a "City Hall and Jail Building."

The plot of land, at 110 South Bradford Avenue, was purchased in February 1940 for a sum of $2,000. At the end of the month, on February 27, an impressive groundbreaking ceremony was held, featuring a speech by Southern California WPA administrator Herbert C. Legg. Ultimately costing $40,000, the building was finished several months later. The building served as city hall until October 1974, when a new facility was constructed several blocks away. Now serving various purposes, the building (which was declared

Placentia's former city hall, which was designed by W. Horace Austin and Harold C. Wildman, was constructed using WPA aid in 1940. The building also housed Placentia's jail and fire department. Today, it is listed as a local historic landmark. *Photo taken by the author.*

a city historic landmark on April 12, 1997) is still standing, appearing much as it did in 1940.

Although bonds were issued by Placentia for the construction of a new city hall, the city was adamant about not issuing bonds for new school buildings during the 1930s. The city was incredibly proud of its "debt-free" school rehabilitation program, which resulted instead from special taxes being authorized. In four years, more than twenty buildings were constructed at the city's various schools.

Bradford Avenue Elementary School, located near Primrose Avenue, was originally constructed in 1913. Although this building survived the 1933 earthquake, it burned down on October 10, 1934, under mysterious circumstances—some local residents reported hearing explosions as the schoolhouse burned. Placentia quickly set about creating plans for a new school to be built on the site. Architect T.C. Kistner designed three new buildings, for which a total cost of $170,000 was estimated.

Bond elections for these new structures were struck down multiple times by local residents, who instead favored the tax hike. A kindergarten building, valued at $30,000, was the smallest of Kistner's three structures, while a new

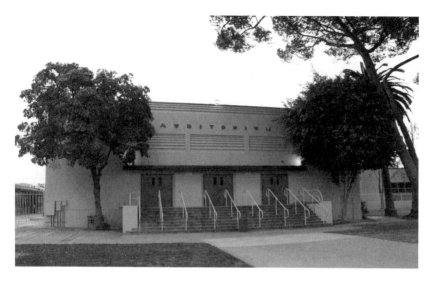

This auditorium was originally part of Bradford Avenue Elementary School when it was dedicated in 1937. Architect T.C. Kistner's design was described as "ultra modern" at the time. Additional funding was provided by the PWA. Today, Bradford Avenue Elementary School's three New Deal buildings are part of Valencia High School. *Photo taken by the author.*

In this photograph, Valencia High School's main building is seen shortly after it was constructed in the late 1930s. As with nearby Bradford Avenue Elementary School, T.C. Kistner was the school's architect. Kistner also designed a gymnasium and pool for the high school. *Photo courtesy University of California.*

eight-room classroom building cost the city $50,000. The pride and joy of the new Bradford Avenue School, though, was the auditorium. Designed in a style that was described as "ultra modern" at the time, the $90,000 building is an exceptional example of Streamline Moderne architecture. Seating 986 people, the auditorium was dedicated on April 29 and 30, 1937. For all three buildings, the PWA helped to finance construction.

Immediately to the north of Bradford Avenue School is Valencia High School, which was founded in 1933. Residents of Placentia created a petition that year to create their own high school so that locals would no longer have to travel to Fullerton to attend classes. By 1938, the school had already constructed a new administration building and gymnasium, and two large wings were added to the school's main building shortly thereafter.

Like Bradford Avenue School, T.C. Kistner also designed the buildings at Valencia High School. The administration building, built in 1935 as the first building at the new high school campus, was funded by SERA and cost $43,695. The project provided jobs for thirty local residents. In 1938, large wings (including one for the science department) were added to the administration building. Designed in a Streamline style that complements the nearby Bradford Avenue School, the high school buildings appear slightly more reserved and simplistic.

In 1937, Kistner was again hired to design the school's $38,275 gymnasium, followed by a $22,000 outdoor swimming pool. While the gym is still standing, the pool has since been relocated. For these buildings, PWA funding was used. When construction was completed in 1938, Placentia prided itself in having one of the finest small high schools in the state. In 1964, Bradford Avenue School closed, and Valencia High School took over the former elementary school's buildings. Today, the fact that Valencia High School occupies both a high school campus and an elementary school campus built during the 1930s makes it a very important addition to Orange County's New Deal architecture.

Two other schools in Placentia, Baker Street School (later renamed Chapman Hill School and located on Santa Fe Avenue) and La Jolla Junior High School (located at Melrose Street and La Jolla Street) were also reconstructed during the mid-1930s, with plans also drafted by T.C. Kistner. However, neither of these schools still stands, so the exact extent of their remodeling is unknown.

Brea

Named after the Spanish word for "tar," the city of Brea was incorporated in 1917 after the merging of two previous towns, Olinda and Randolph. For much of its history, Brea's economy consisted almost entirely of vast amounts of oil production, and by the 1930s, the city had a steady population of 2,500 people. Although fairly far from the epicenter of the 1933 earthquake, Brea still had to comply with the state's new earthquake standards, and the city's two elementary schools and high school were deemed hazardous. Over the next few years, each of these schools was modified and reinforced in accordance to the new law.

Brea Grammar School, the city's main elementary school, was located at 400 North Brea Avenue. Built between 1916 and 1918, the school originally featured large Neoclassical pillars at its main entrance. After the earthquake, these columns were deemed unsafe, so in late 1935, the city acquired PWA funding in order to reconstruct the school's main building. Los Angeles–based architect Theodore C. Kistner was hired for the project, and his new school featured a Spanish Colonial design that is much more fitting for Southern California. By 1936, federal funds had been acquired to cover part of the cost of the school—totaling $96,900—and the school reopened shortly thereafter. Today, the campus is occupied by Brea Junior High School, and Kistner's structure continues to appear much as it did when he designed it.

Brea's second elementary school, opened in 1921, was the Laurel School, which is located at 200 South Flower Avenue. Opened to accommodate the rapidly growing population in the southern part of the city, the school featured a similar design as Brea Grammar School. In 1938, after the Grammar School had been reconstructed, a similar building program was proposed for Laurel School, and the PWA provided funds to refurbish the school in a very similar manner—today, it features the same style of Spanish Colonial architecture that is seen at the Grammar School. Also part of the proposed building project were a new city park and auditorium for the Grammar School, neither of which appear to have been accomplished.

The third of Brea's schools to be modernized following the 1933 earthquake was Brea-Olinda High School, for which the cornerstone was originally laid on October 20, 1926. As was the case with Brea's two elementary schools—and most of Orange County's other high schools at the time—a neoclassical design was chosen. And like the two elementary schools, the large columns

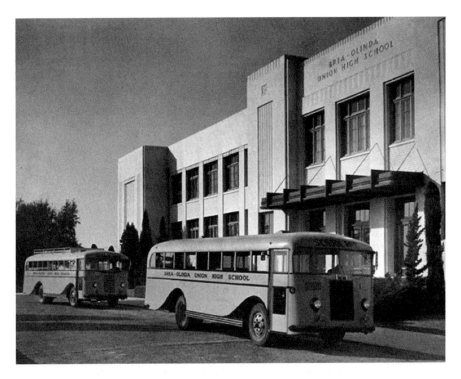

Brea Olinda High School was extensively remodeled following the 1933 earthquake, as can be seen in this historic photo. Torn down in the 1980s when the school moved to its current location, the site where the school once stood is now the Brea Marketplace mall.

at the front of the school were deemed unsafe under the new building codes. In 1937, as soon as work was done on the Grammar School, a complete redesign of the high school was planned.

Over the next few years, more than $263,000 was spent on bringing the high school up to modern standards. Local bond elections, PWA grants and even some WPA aid all went toward this new school. In place of the main building's Roman columns was a new Art Deco façade, featuring monumental pilasters that simultaneously managed to feel modern and classically inspired—leading some architectural historians to label the style "Greco Deco." In the early 1980s, the school site was sold to raise funds for the current Brea-Olinda High School, which was constructed between 1986 and 1989. The site of the original high school is now the Brea Marketplace mall; had the high school survived, it would have been one of the finest examples of monumental 1930s architecture in the entire county.

A 1938 U.S. Treasury report listed Brea as the potential site of a $70,000 post office; however, Brea was not one of the final cities selected by the government to receive such a building.

Yorba Linda

Although the city of Yorba Linda can trace its roots back to the 1830s, the city itself would not be incorporated until 1967. At the time of the Great Depression, the population was only several hundred people, and the town was still very rural—not the type of environment where one would expect New Deal projects to be carried out. However, in the wake of the 1933 earthquake, local residents quickly proposed the idea of constructing a new library using government funds.

In 1934, a $1,500 bond was proposed, with the remainder of the cost for such a building coming from the federal government. The town sought to spend between $5,000 and $7,500 on the building; however, the architect hired by the city drew up a $9,000 library—much more than the city could afford. The building included a "patio, plenty of shelf room, a sound-proofed reading room, and all the fixins.'" The architecture was designed as "California" style with an adobe frame and stucco exterior.

Knowing that the WPA would never agree to construct a $9,000 library, the city quickly revised its plans and reduced the cost by a third. However, this was still not enough to win the federal government's approval, and the WPA rejected the city's application in February 1936, crushing the small town's dreams for a modern library.

CHAPTER 4

Central Orange County

Anaheim

Although Fullerton is said to have received the most New Deal aid of any city in Orange County, Anaheim received nearly as much assistance during the Great Depression, and many landmarks from this era are still standing. The core of development during this time was Anaheim's extensive school rebuilding program, beginning with a new high school and continuing with reconstruction of many of the city's elementary and junior high schools. Anaheim was also the recipient of several works of public art and other governmental buildings.

Anaheim Union High School, founded in 1898, is the third-oldest high school in Orange County, after only Santa Ana High School and Fullerton Union High School. The school has occupied its current site since 1911, when eleven acres were purchased for $105,000. A stunning Greek Revival–style campus was opened in 1912, and in the early 1920s, an auditorium, gymnasium and other buildings were added in the same architectural style.

The classically inspired campus served the Anaheim community until 1933, when the March 10 Long Beach earthquake damaged many of the school's wood-structured buildings. Although the damage was not as extensive as that suffered by many other Orange County schools, officials

recognized the fact that another earthquake had the potential to be devastating. Initial plans called for repairing and reinforcing the existing auditorium and administration building; however, it was determined that entirely reconstructing the building would actually be less expensive.

Architect T.C. Kistner began to draft plans for a new structure (which would contain an auditorium, administrative offices, a library and study spaces), as well as detailing repairs for the gymnasium, machine shop and music building. A special election was scheduled for December 18, 1933, to issue bonds totaling $275,000. The two-thirds majority necessary to pass the measure failed; however, once Kistner's plans for a striking Art Deco structure were unveiled in April of the following year, the issue was again put up to a vote, and on May 15 the bonds were authorized with a 2,106–813 vote. Additional funds were also sought from the RFC and CWA, but neither materialized.

As funding was being sought for the new school building, a team of twenty SERA laborers worked to raze the original auditorium. During the process, the original cornerstone that had been placed on February 10, 1912, was opened; some of the newspapers and other items were placed in the cornerstone of the new building. The SERA crew also moved the original language and commerce buildings to make way for the new structure.

Legal issues plagued the new building. Kistner's designs were not authorized by the state until December 1934. As the foundation for the building was being laid in the early months of 1935, it was also announced that the PWA had authorized funds that had been applied for eighteen months prior. After some confusion, it was determined that the money raised from bonds, in addition to the PWA's $110,000 grant, could be used, leaving the high school with a total budget of $385,000.

Construction finally began on September 9, 1935. Under contractor William C. Crowell, PWA workers picked up where the SERA crew had left off. Work progressed rapidly, and at any given time there were between 100 and 250 workers on the job. By mid-August 1936, the administrative offices and library had been completed, and the auditorium was finished soon after.

The building's 1,600-seat auditorium was used for the official dedication of the new high school on the evening of November 18, 1936. The school was celebrated for its beauty and modern, earthquake-proof construction. Of particular note is the fact that it was the first school in the entire country heated entirely by electricity. The building's interiors, some of which were finished in chrome and mahogany, were also praised.

Work on the high school did not stop with the erection of the new administrative building and auditorium. At the beginning of December,

Anaheim High School, designed by T.C. Kistner, features several buildings constructed during the New Deal. The main building, seen here, has a cornerstone that commemorates the PWA's involvement on the project. Elsewhere on the campus, an Art Deco gymnasium was constructed around the same time. *Photo taken by the author.*

only two weeks after the new building's dedications, WPA crews began clearing debris from the old school buildings and landscaping the campus. The $7,000 project, $2,476 of which was provided by the WPA, featured the construction of sidewalks, the planting of shrubbery, the installation of sprinklers and the placement of a sunken fountain in the school's central courtyard (which was replaced in 1964).

A few days following the announcement of the WPA's work, a contract for $97,945 was let to L.R. Wilson for the construction of the first unit of a new gymnasium, financed in part by the PWA. Work began on January 4, 1937, and was supposed to be completed within five months. Delays occurred that forced the city to apply for an extension from the PWA, but the auditorium was completed later that year.

Today, the gymnasium, auditorium and main administration building are all still standing. Kistner's plans are representative of the monumental Art Deco style of architecture, with some influence from the Streamline style, as are many of the other buildings he designed around the county at this time. One of the few local high schools built during the New Deal

This cartoon shows PWA workers constructing Anaheim Union High School's auditorium, which was completed in 1936. Today, the building is known as the William A. Cook Auditorium (Cook was the director of the school's band and helped implement music programs at various schools around the city).

Opposite: Today, the Cook Auditorium is one of the most impressive examples of New Deal architecture in the county.

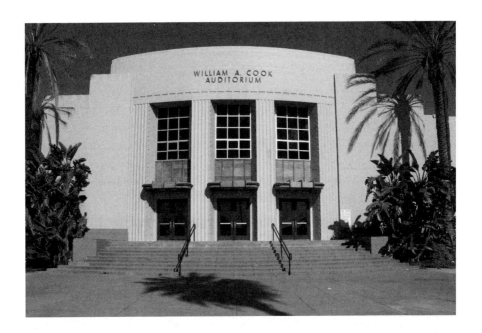

that is still standing, Anaheim High School, is an integral part of both the WPA and PWA's influence in Orange County. A cornerstone still reads, "Anaheim Union High School, Erected Anno Domini MCMXXXV, PWA Docket 8291."

Anaheim Union High School wasn't the only school to receive federal aid during the New Deal. The entire Anaheim Elementary School District benefited heavily from the PWA and WPA, having new facilities constructed and existing facilities retrofitted to comply with earthquake standards. In March 1936, contractors estimated the total cost of improvements necessary within the city to be $487,520. Over the following years, a systematic effort was made to modernize all of the city's educational facilities.

The cornerstone of this program was a massive PWA grant that helped to refurbish schools that had been damaged by the 1933 earthquake. In addition to the existing schools that were rehabilitated, two entirely new schools were also added to the community. The larger of these, John C. Fremont School, was demolished around 1980 and represents a terrible loss of New Deal architecture in the county.

Located at 616 West Center Street (now Lincoln Avenue), the school originally opened in 1901 and was extensively remodeled in 1923. Although most of Anaheim's schools were not irreparably damaged by the Long Beach earthquake, the Fremont School sustained very serious damage and was

almost immediately condemned by state architects. Local citizens realized that immediate action was necessary to raze the outdated structure.

As the largest project in Anaheim's citywide school rehabilitation program, a $195,000 bond was proposed to help construct a brand-new structure. Seldom was there a more intensely debated civic battle during this time, and the local papers were filled with pleas from parents begging voters to allow for the bond. One commentator went so far as to call it "heartless…to gamble with the lives of children" if the bond was rejected.

The bond election was held on February 9, 1937, and voters overwhelmingly (1,091 for to 515 against) supported it. The new school, as detailed by the school board, was to feature nine classrooms, a library, an auditorium and other amenities, with plans being drafted by the firm of Marsh, Smith and Powell. The architectural trio, who were the head architects at the University of Southern California for a time, are perhaps best remembered for their New Deal schools, which include Hollywood High and South Pasadena High.

Demolition of the old John C. Fremont School began almost immediately and was completed by mid-1937. However, finding relief aid to finance the construction of a new building in its place proved much more difficult. Although President Roosevelt himself offered his assurance of federal funding, it would take until October 19 for the PWA approval to be made public. Due to further bureaucratic delays, it would take until the following year for construction to actually get underway.

In the meantime, two other projects were taking place on the same campus. A shop building was being constructed for the Fremont School at a cost of $39,300. Located off of Citron Street just south of Lincoln Avenue, the new structure was located next to the Citron School. While the shop building was being constructed, relief crews also worked on converting the Citron School (formerly an elementary school) into a cafeteria for the Fremont School at a cost of $27,969. Both of these projects were completed by the spring of 1938, just as work was beginning on the school's main building.

Final federal approval for the new Fremont School came on May 9, 1938, and a contract for construction was let on June 2. Although construction was initially estimated to take fifteen months, the structure was ready to be dedicated on April 25, 1939. Costing $330,000, Fremont School did not lack any modern amenities. Inside of the building's streamlined exterior, the school featured a full intercom system, a dark room, modern motion picture equipment and an eight-hundred-person auditorium.

Another hallmark of the John C. Fremont School that contemporary writers were quick to pick up on was its beautiful artwork. Inside, the

Despite its low quality, this image is significant as it represents the only known photograph of Arthur Ames's work at John C. Fremont School. Ames was commissioned to paint two murals in the foyer of the school's auditorium. The murals resided in the school for four decades, from 1939 to 1979. *Photo courtesy* Los Angeles Times.

school's main hallway was covered in "mosaics and murals," according to one source. More specifically, prolific New Deal artist Arthur Ames, who was responsible for Anaheim's post office murals and one of Newport Harbor High's mosaics, was commissioned by the FAP to design two large murals for Fremont School. One depicts students gathered around a teacher, while the subject of the other is unknown. Ames himself designed the pieces but did not actually paint them.

Following the 1979 school year, it was announced that Fremont School would be closed due to low attendance and high maintenance costs. Outcry came over the fact that a majority of students were Hispanic; however, no one at the time considered the historic nature of the property. Initial plans called for a cultural center to be built on the site, but funding could not be raised. In the end, a housing tract was constructed.

Also constructed during this time was Benjamin Franklin Elementary School, located at 521 West Water Street. Plans for the school were drawn up by Marsh, Smith and Powell as early as 1936, but construction did not begin until two years later. The main building, which consists of administrative offices, eight classrooms and a kindergarten, cost approximately $70,000 to build; some of this cost was covered by the PWA. As soon as it was completed, the same architectural firm also designed an auditorium, which was added to the building. Although not as physically impressive as nearby Anaheim High School, Franklin School shows that not all projects during the New Deal were extravagant—many were small projects that simply served a local community's needs.

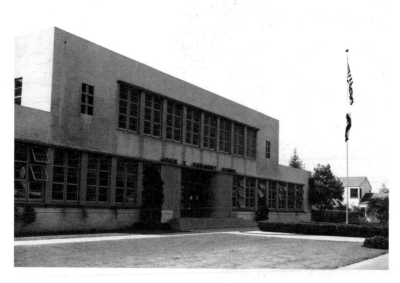

John C. Fremont Junior High School represents one of the biggest losses of a New Deal structure throughout the county. Torn down around 1980, the building was a wonderful example of the Streamline and PWA Moderne styles. Fortunately, several other schools from this era still survive in Anaheim.

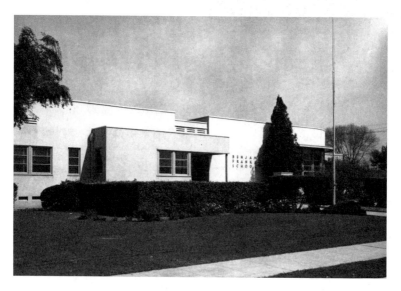

Benjamin Franklin Elementary School in Anaheim was one of the few new schools constructed during the New Deal—most other schools were renovated or rebuilt following the 1933 earthquake. The building's design is very subtly Streamline Moderne, setting it apart from many other local schools.

Several other schools were refurbished by the PWA although not entirely reconstructed following the 1933 earthquake. Anaheim's first elementary school, Central Elementary School, was constructed in 1879 for $10,000. In the 1910s, the original Victorian-style building was replaced by a more modest, one-story structure. Located at 233 Chartres Street (now Lincoln Avenue) between Emily Street and Philadelphia Street, this school was renamed George Washington Elementary School on the bicentennial of our first president's birthday—February 22, 1932.

Having suffered minor damage during the 1933 earthquake and being deemed unsafe in the case of future earthquakes, the initial plan called for "structural bracing" to be carried out at the school. Due to Anaheim's numerous other projects, however, work was not begun until the summer of 1938. The building's foundation and roof were kept, while all of the building's walls were replaced. The new walls, coupled with the new equipment installed in the building's ten classrooms, totaled $53,900. A PWA grant was filed for, and the construction was scheduled to be completed by the first day of 1939.

George Washington Elementary would close its doors in 1978, and in 1980, the building was converted into a community center. In 1998, the George Washington Community Center closed, and three years later, the site was cleared for George Washington Park. Dedicated on March 16, 2002, the park contains a plaque detailing the history of the site.

Another of Anaheim's public schools, Broadway School, was also refurbished by the PWA. Located at 412 East Broadway, the site is now occupied by a Baptist church. Broadway School was constructed in 1908 as the Anaheim Primary School and renamed in 1910. The rear half of the school was added in 1914. By the 1930s, it was already the oldest existing school in the Anaheim City School District. Due to its age, more work was required than for other schools in the district, and a special WPA application was filed for.

On December 21, 1937, a WPA crew of twenty-four men began removing the brick exterior of Broadway School in order to refinish the building with plaster. Additionally, the building's distinctive cupola was removed, and slight alterations were made to the rear of the building. The total cost of the project was estimated to be $11,000, $3,000 of which was provided by the school district and the remainder by the WPA.

The refurbishment project was larger than anticipated and quickly ran out of funds. On July 14, 1938, the WPA granted an additional $6,000 to finish the exterior work, as well as modernizing and enlarging the school's

classrooms. All work was completed in time for the start of the 1938 school year. Despite the extensive work carried out, Broadway School would remain open only until 1951, when it was replaced by Thomas Jefferson Elementary School a few blocks away. In 1959, the former school was converted to an administrative center for the school district, a purpose it continued to serve until its demolition in the late 1980s or early '90s.

The PWA also refurbished other local schools, although the extent of their work is largely unknown. Lincoln School received a new roof shortly after the Long Beach earthquake, and new curtains were purchased for its auditorium. Work was also done at the La Palma School, a segregated school for Mexican children. It also appears that work may have been done at Horace Mann Elementary School; however, as none of these buildings are still standing, it is impossible to know exactly how much work was done.

Schools in other local districts were also refurbished under the New Deal. One such school was the Centralia School, located at 7341 Lincoln Avenue between Knott and Western Avenues in what is now Buena Park. Although the plot of land is now a senior apartment complex, the first school built on the site dated back to 1899. A new building, designed by Richard M. Bates Jr. and constructed by Steed Brothers Inc., was funded by a $35,000 school district bond and a $30,000 PWA grant, all of which was set aside as early as March 1935.

Officially dedicated on January 28, 1938, the new school featured six classrooms, a 250-seat auditorium and a library. Also included in the PWA project were the construction of a garage for the school bus and the installation of playground equipment for students. The school was eventually closed in 1984, and the historic 1930s building was demolished in about 1991.

Another local school originally outside of Anaheim's city limits is Loara Elementary School, located at 1601 West Broadway. During the 1930s, Loara was its own community with its own school district, allowing it to make its own decisions regarding relief spending. On October 26, 1935, the small community voted on an $18,000 bond issue to go along with $14,715 worth of federal aid it had been offered. By a vote of 130–45, Loara issued the bonds to fund a new elementary school.

Originally on the site stood an impressive Victorian schoolhouse, constructed in 1888. The new school, built sometime following the issuance of the bonds in 1935 or 1936, features a radically different streamline style, albeit very subtle in nature when compared to other local schools from the era. It was designed by Richard M. Bates Jr., the same architect who designed Centralia School. Although some recent additions have compromised the

architectural integrity of the building slightly, it is still a fine example of simpler New Deal architecture.

Buildings other than schools were also built during this time. Much like the post offices in Orange and Huntington Beach, Anaheim's post office faced many struggles before finally coming to fruition. Prior to the 1930s, Anaheim's post office had been housed in a large building at the corner of Oak Street and Clementine Street. Citizens had long sought a new structure due to the rapidly growing size of the city, the earliest plans for such a structure dating back to the Hoover administration.

By late 1933, postmaster J.H. Whitaker had hired architect Frederick H. Eley, a Santa Ana native, for the building, but the project didn't take off until May 5, 1934, when the federal government purchased a lot of land on Broadway between Lemon Street and Anaheim Boulevard (next to Anaheim's Carnegie library) for $16,500. However, due to political red tape (which plagued so many New Deal–era projects), bids for the construction of the post office were not opened until September 3, 1935. In the months that had passed, the budget of the project had been cut by the Treasury Department from $130,000 to only $90,000.

Eley's design for the building, unveiled in August 1935, featured a minimalist streamline style that was so popular for public buildings during the era. Constructed out of concrete and finished with stucco, the design was met with some scorn, and a local newspaper went as far as to state that the building would "not add anything to the architectural beauty of the city." The design featured a mezzanine floor and a full basement to provide additional space. The public lobby was decorated with tile and marble, with the rest of the building being finished in wood.

On September 13, 1935, the construction contract was awarded to G.F. Campbell and Charles P. Kelly, and an official groundbreaking ceremony featuring Mayor Charles H. Mann was held on October 18. Work progressed without any problems, and acting postmaster Louis H. Hoskins announced that the formal dedication of the new $86,000 post office would be held on May 29, 1936. Featured in the ceremony were the mayor, local government officials, civic leaders and family members of Anaheim postmasters dating back to 1861.

A total of six hundred people attended the official opening of the post office, at which the keys of the building were presented to Dana Q. McComb, a representative from the U.S. Treasury Department. To celebrate the momentous occasion, a special cachet was designed, featuring the façade of the new post office and the date of the building's dedication. Approximately

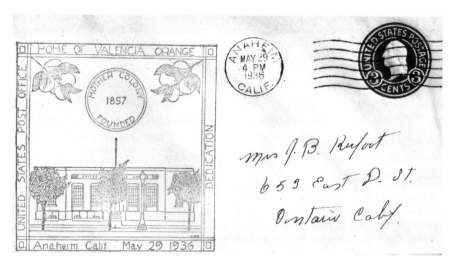

This envelope cachet was designed for the grand opening of the Anaheim Post Office. It is postmarked May 29, 1936, the day on which the office was first opened to the public. The logo, in addition to a line drawing of the new structure, advertises the city as the "home of [the] Valencia orange." *Author's collection.*

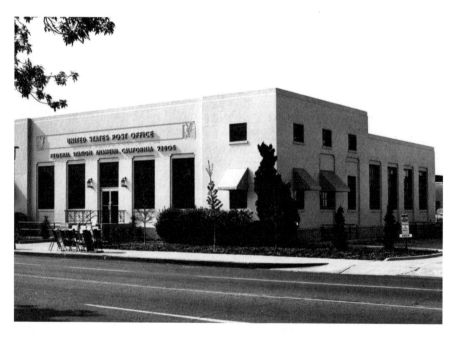

Anaheim's post office was begun in 1935 and dedicated the following year. The building was renovated in 1970 but demolished in 1996. This is the only one of Orange County's New Deal post offices that is no longer standing. The Anaheim Muzeo currently occupies the site. *Photo courtesy University of California.*

one thousand letters were mailed on the first day in order to receive the special cachet.

Renovated in 1970, the Anaheim Post Office continued to serve the community for six decades. However, by 1995, Anaheim was undergoing a major redevelopment program, and many local residents found the building outdated and unsightly. In 1996, the building that had thrilled the community over half a century earlier was demolished; today, the Anaheim Muzeo occupies the site.

There was a multitude of projects proposed in Anaheim during the New Deal that, for a variety of reasons, never ended up materializing. One of the ideas that continually recurred was the construction of a new fire station—instead of having the fire department operate out of city hall. As early as February 1935, the city-owned land at the northeast corner of Broadway and Los Angeles Avenue (now Anaheim Boulevard) was set aside for such a building, which would be partially funded by the PWA. Two years later, the same idea was still being discussed in local newspapers, and maps created at the time list the plot of land as the future site of a fire station. However, for unknown reasons, the station was never constructed.

Other ideas were also proposed by prominent locals. A new civic auditorium was discussed, but the recent construction of Anaheim High School's auditorium put a quick end to the matter. An underpass beneath the city's railroad tracks, a tunnel for students under La Palma Avenue in front of the Horace Mann School and a roof for the theater in Pearson Park were also very popular ideas, but public support and money could not be raised for any of them. Potential projects ranged from the fanciful (the construction of a golf course in Anaheim) to the mundane (the construction of storm drains and sidewalk repairs).

In addition to schools, a post office and other municipal improvements, Anaheim also received several public works of art during the New Deal. The most prominent of these pieces is the larger-than-life statue of famed Polish actress Helena Modjeska in Anaheim's Pearson Park. Modjeska, one of the most renowned Shakespearean actresses in history, moved to Orange County in 1888 (the land she owned was later renamed Modjeska Canyon, where her house is now a museum). By the early 1930s, the city of Anaheim was looking to erect a statue of what it called its "most famous resident."

German-born artist Eugene Maier-Krieg was selected as the sculptor of the project, which was funded in large part by the Public Works of Art Project. Additional funding for the statue came from SERA, the Anaheim Rotary Club and the city of Anaheim itself.

Seen in this vintage photograph is Anaheim's statue of Helena Modjeska in Pearson Park. Eugene Maier-Krieg sculpted the piece under the Public Works of Art Project in 1934, although it wasn't unveiled until the following year. Modjeska is depicted as Mary, Queen of Scots, one of her most famous roles. *Photo courtesy University of California.*

Although the statue, which was made in Hollywood, was nearing completion in early 1934, the project would face delays of over a year before it was finally ready to be installed. A large ceremony to celebrate the unveiling of the statue was scheduled for September 15, 1935, at 4:00 p.m. The master of ceremonies was Merle Armitage, who was the regional director of the Public Works of Art Project. Anaheim mayor Charles Mann accepted the statue from the federal government.

The unveiling of the statue attracted between 1,500 and 2,000 people, among them Eugene Maier-Krieg, the sculptor of the work. Additional speeches were given by Frank Merriam, governor of California at the time, and Felix Modjeska, grandson of the actress. Also present were many German and Polish organizations, celebrating the life of the great actress.

The finished statue, which resides in the northeast corner of Pearson Park, stands an imposing twelve feet tall. Various plaques can be found on the statue's base, listing the artist, the date on which it was unveiled and biographical information about the subject. A more recent plaque identifies

Top: In addition to the Helena Modjeska statue, the Public Works of Art Project also commissioned a three-panel mural for the Anaheim Public Library. The artist was Arthur Ames, who was also responsible for Newport Harbor High School's mosaics and the murals at John C. Fremont Elementary School. This panel depicts a local man holding a shovel. *Photo taken by the author.*

Bottom: After recent acts of vandalism, the two smaller panels of Ames's mural were removed from display at the Anaheim Public Library's Central Branch. Originally located at Anaheim's Carnegie library, they were moved when that structure was demolished in 1963. This panel shows a woman with a bouquet of flowers. *Photo taken by the author.*

the statue as the oldest public work of art in Orange County, despite the fact that several other New Deal pieces of art were finished slightly earlier. In addition to the massive figure of Helena Modjeska, the statue also features four vineyard workers, in memory of the agricultural economy upon which Anaheim was founded.

Anaheim's other piece of New Deal public art is a three-panel mural that was commissioned by the PWAP to hang in the city's library. The painting, which is by Arthur Ames (also known for his work at Newport Harbor High School and John C. Fremont School), depicts three idyllic scenes from local rural life. The center panel, which is the largest, shows rolling hills with orange groves, oil derricks and a hydroelectric plant. The two other images, each about half the size of the center panel, show a man holding a shovel and a woman holding a bouquet of flowers, respectively. Each of the three panels is in a hand-carved wooden frame.

When the Anaheim library was relocated in 1963, the murals were also moved. Until recently, the man and the woman were both hanging in the Central Branch of the Anaheim Library, with a small sign chronicling their history. However, recent incidents of vandalism have forced them to be removed for conservation purposes. The central panel currently hangs in the reading room of the Anaheim Muzeo.

Anaheim also received federal aid for the refurbishment of one of the city's parks. La Palma Park, covering twenty-one acres, is located at 1151 North Anaheim Boulevard, midway between downtown Anaheim and Fullerton. Largely financed through government relief aid, the park cost $195,000 to construct. Anaheim initially sought federal funding for a park in 1937, and on December 16 of that year, ground was broken. In addition to much of the funding, the WPA also provided sixty-three laborers for the project.

The park's most impressive feature is its baseball stadium (renamed Dee Fee Field in 1987), featuring a grandstand capable of seating three thousand people. The first baseball team to use the stadium was the Seattle Rainiers of the Pacific Coast League during the spring training season of 1939. In fact, construction of the playing field was rushed to completion in order to be ready for the Rainiers' first home game in March of that year.

The park was not officially dedicated, however, until August 5, 1939. In addition to the baseball field, La Palma Park featured a playground for children and a lily pond (which has since been replaced by a parking lot). The dozens of palm trees used for landscaping were primarily donated by local residents. Many of the trees, which were over fifty years old when moved to the park, are still standing today. Prior to the park, the site had

CENTRAL ORANGE COUNTY

The large center panel of Arthur Ames's library mural is currently located in the Anaheim Muzeo's reading room. Each of the three panels is in a hand-carved wooden frame. This piece of the mural depicts orange groves and oil wells—two of the largest economic forces in Orange County's early history. *Photo taken by the author.*

La Palma Park in Anaheim was one of the county's numerous parks constructed during the New Deal. Many of the palm trees planted during the 1930s still stand; however, the pond has since been replaced by a parking lot.

been the location of the California Valencia Orange Fair, a large exhibition tent dedicated to the county's namesake crop.

At the August 5 dedication ceremony, many of Anaheim's city council members and other officials were in attendance, in addition to local chapters of the United Spanish War Veterans and the Veterans of Foreign Wars. The main speaker was local WPA administrator Herbert Legg, who called the park "a lasting testimonial to the spirit of a people who refused to be downed, who put their millions of unemployed to work creating such monuments as this." Following his speech, a concert, model boat regatta and baseball game were held.

Orange

The city of Orange was founded in 1869 and incorporated nineteen years later, on April 6, 1888. What makes Orange unique in the county is its extremely high concentration of historic buildings; in particular, the Orange Plaza primarily features buildings that were constructed prior to 1930. This, combined with the fact that the city was relatively unharmed in the 1933 earthquake (when compared to communities closer to the epicenter), means that Orange did not have a large amount of New Deal aid. That said, there were still several significant improvements made throughout the city.

When Orange City Park was founded in 1933, it was Orange's first public park (other than the city's famous Plaza, which can hardly be considered a park). However, Orange residents began looking into the possibility of having a large public park as early as 1927 (but a bond election held that year failed to receive a majority of the vote). It took an additional six years for the city to purchase seventeen acres of land along Santiago Creek, just a few blocks south of the city's historic plaza. As soon as the land was acquired, SERA workers began clearing out the park and adding infrastructure.

By December 1934, CWA and SERA workers had already landscaped much of the park with trees and shrubs, as well as added tennis courts and a baseball diamond. Work also began under the SERA on the construction of a community swimming pool. Construction of the swimming pool complex, which features two swimming pools, locker rooms and other facilities, was continued by the WPA in 1935 and 1936. The Orange Plunge, as it is sometimes called, was designed in a classically influenced Moderne style that is both traditional and contemporary.

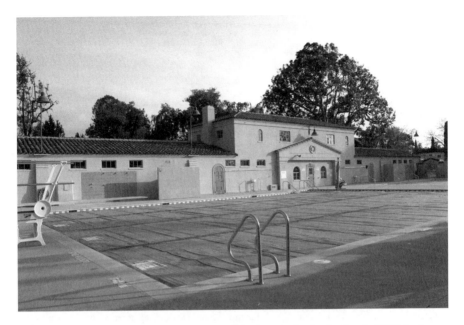

Adjacent to the Hart Park bandstand is a municipal pool, also funded by the WPA in the mid-1930s. Elsewhere in the park, a stone pilaster has a plaque commemorating the WPA's work there. The Santiago Creek was channelized where it cuts through the park, and this area is now used for parking. *Photo taken by the author.*

The plunge was dedicated along with the rest of the park on May 1, 1937; however, development of Orange City Park was far from done. The city of Orange and WPA laborers erected a band shell directly to the west of the pool, which was completed in 1938. A plaque on the structure commemorates the band shell's original construction, as well as its enlargement as part of Orange's centennial in 1989. A nearby pilaster features a plaque that reads, "BUILT BY UNITED STATES WORK PROJECTS ADMINISTRATION 1940" on one side and "ORANGE CITY PARK, APRIL FIRST, 1940" on the other.

As with several other Orange County parks, Orange City Park was built along the banks of Santiago Creek, and the creek was consequently channeled as the park was being developed. Today, the park's parking lot sits in the creekbed, which is lined on either side by Arroyo stone walls, built by hand in the 1930s. These walls, with their striking staircases leading up into the park, are one of the more impressive features of New Deal architecture in Orange County. Since 1964, the park has been called W.O. Hart Park.

Located in W.O. Hart Park (formerly known as Orange City Park) are several structures that date to the 1930s. The bandstand, shown here, was one of the first buildings to be constructed by relief agencies. Throughout the New Deal, various agencies (including the CWA, WPA and SERA) improved the park. *Photo taken by the author.*

Located at W.O. Hart Park in Orange, this pilaster commemorates the work carried out in the park by the WPA. Similar plaques can be found on other buildings constructed by the agency throughout the county. *Photo taken by the author.*

It is also humorous to note what the public perception of Hart Park was during the Depression. A 1938 *Los Angeles Times* article states that work on the park was carried out by "every alphabetical relief arrangement set up by the federal government." While obviously an example of hyperbole, it does speak to the large number of independently operating federal agencies during this time period.

Another park was also improved on the outskirts of the city of Orange at this time. Irvine Park holds the distinction of being Orange County's first regional park. A popular site for picnics since the late 1850s, it was given to the county by the Irvine family in 1897, at which point it became known as Orange County Park. In 1928, its name changed to Irvine Park, and the early 1930s saw a wave of buildings designed by Frederick Eley (who would go on to design WPA-era schools in Santa Ana). Although sometimes identified as WPA buildings, the Eley-designed buildings (including the exhibition hall) actually predate the New Deal.

By the mid-1930s, Irvine Park had much of its infrastructure in place, leaving little work to be done by federal relief programs. However, two picnic areas—one near the park's entrance and another next to the stage—were constructed between 1935 and 1936 by WPA workers. Each contains fireplaces, sinks and barbecues constructed from river stones. Also at each picnic area is a plaque commemorating the WPA's involvement.

Additionally, the WPA paved roads and added curbs throughout the park. Arguably the most important work done by the WPA in Irvine Park, though, was the channeling of Santiago Creek, which had been the site of major floods in the preceding years. Although the 1938 flood was devastating to many parts of Orange County, the WPA's work prevented it from potentially being even worse.

Nearer the Plaza is the Orange Post Office, which was built simultaneously with the Anaheim and Huntington Beach Post Offices. Orange's first post office was founded in 1873, although for several decades, it occupied various buildings and storefronts throughout the city. By the early 1930s, local residents felt that the city required a more permanent structure, and federal funding was sought for such a building.

In May 1934, a lot at the corner of Chapman Avenue and Lemon Street was purchased for a sum of $10,000. This had formerly been the site of the famed Rochester Hotel, which was constructed in 1887. The beautiful Victorian building had been home to Orange County's first college, the Orange County Collegiate Institution, from 1889 to 1891 before spending the next forty years as a hotel. The Rochester was finally torn down in June 1931.

Plans for the Orange Post Office were drawn up by the Office of the Supervising Architect, which was headed by Louis A. Simon during this time. Construction on Orange's federal building progressed rapidly, and by August 1935, the post office was open and operating. For the grand opening, a special envelope cachet was designed, depicting the building surrounded by orange groves and mountain ranges. Simon's design for the building is very similar to the Huntington Beach Post Office and former Anaheim Post Office—while obviously influenced by local Spanish Colonial Revival architecture, the building still has a very simple, utilitarian feel to it that is representative of the Great Depression.

In 1971, Orange opened a new central post office on Tustin Avenue, and the New Deal structure was renamed the Plaza Station Post Office. In recent years, the station has been threatened with closure due to budget cuts, but it appears that it will remain open in the foreseeable future. A plaque on the building commemorates the year the project was begun, as well as the Secretary of the Treasury and Postmaster General at the time.

Several miles west of Orange was once the Orange County Hospital; today, the complex is called the UCI Medical Center. The first buildings on the site were constructed in 1914 in a Classical Revival style. The central location of the hospital allowed it to serve many of Orange County's communities, and it was the largest facility of its kind in the area. With the coming of the New Deal in 1933, the hospital quickly began planning on using funds for additional buildings.

In 1934, M. Eugene Durfee was hired to design a new tuberculosis ward for the hospital. Durfee was one of Orange County's most prolific architects, designing such landmarks as the Kraemer Building in Anaheim and the Chapman Building in Fullerton. The one-story building cost $40,000 to construct; $18,000 was provided by the PWA, with the remainder coming from the hospital itself.

Although nearly destroyed in the 1938 floods, the tuberculosis wing was still standing as late as 1980. However, development in the last few decades at the medical center led to its destruction (along with nearly all of the historic buildings on the site). One red tile–roofed building still remains in the complex, although it is currently unknown whether the building also dates back to the New Deal or if it is a more recent addition.

Orange also had several projects that, while proposed, were unrealized during the New Deal. In 1933, shortly after the earthquake, both an addition to the city's Carnegie library and a new fire hall were suggested by residents. Plans were drawn up; however, it seems that neither of these projects ever

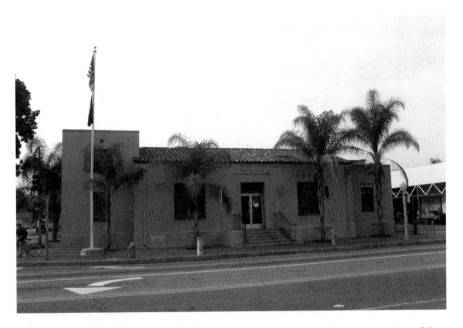

The Orange Post Office is one of three operating New Deal post offices in the county. Like all post offices built during this era, it was funded by the U.S. Treasury and not the WPA. It is one of the few surviving New Deal buildings in Orange, as many of the city's historic structures predate the program.

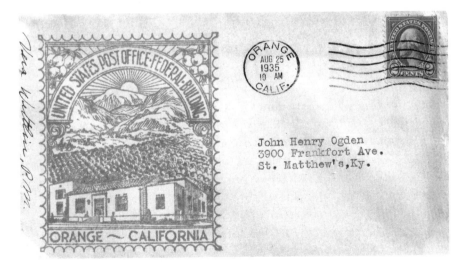

Very similar in design to the cachet produced for the opening of the Anaheim Post Office is this envelope made for the Orange Post Office. Postmarked on the morning of August 25, 1935, this envelope was bound for Kentucky. The cachet depicts an idyllic view of the new building, fancifully set against orange groves and mountains. *Author's collection.*

moved past the planning stage. Another project from this time that did not require federal or even state funding was the installation of a new fountain at Orange Plaza, which took place in 1938.

Olive

Founded in 1812, Olive is a small, unincorporated community located to the east of Anaheim and north of Orange. Although home to fewer than two hundred people today, Olive has a rich and distinctive history when compared with neighboring cities. Over the past 250 years, the community has been home to Spanish ranchos, a prosperous flour mill and citrus packinghouses; however, one of Olive's most significant buildings is the Olive Civic Center, constructed between 1937 and 1939 by the WPA.

By the mid-1930s, Olive, like all communities in Orange County, was struggling under the weight of the Great Depression. In an effort to revitalize the community, the Olive Improvement Association wrote the Jotham Bixby Company, which owned land in Olive, asking for a parcel of land to construct a community center. In early 1936, the company granted land near the Olive Grammar School, and the city quickly began looking to acquire funding for a new building. A special bond election was held in May 1936, and residents authorized the selling of $8,000 worth of bonds by a margin of four to one.

The WPA approved Project No. 465-03-2-167 on August 24, 1937, officially calling the new building a "gymnasium and assembly building" for the Olive Grammar School. Fay R. Spangler of Santa Ana was selected as the architect. Ground was broken for the project on November 1, 1937, and construction began the following week. Initial estimates placed the cost at $15,000; however, skyrocketing prices led to a final cost of more than $88,000. The completed building was dedicated a year and a half later on May 21, 1939, to a crowd of over one thousand people.

An exceptional example of Spanish Colonial Revival architecture, the Olive Civic Center is remarkable not only in the community of Olive but also in Orange County as a whole. There is perhaps no more impressive example of New Deal–era Spanish Colonial Revival architecture in the entire county. While the other original Olive Elementary School buildings were demolished in 1963, the civic center continues to stand nearly unchanged since 1939.

The interior of the building originally served a number of different purposes. A public library capable of housing 1,300 books was in one room, while another provided meeting space for various local clubs. There is also a large gymnasium that features a basketball court, a stage and dressing rooms and formerly offered access to an outdoor tennis court that was also built by the WPA. On the exterior, a bronze plaque reads, "BUILT BY THE UNITED STATES WORK PROJECTS ADMINISTRATION 1940."

Tustin

Although incorporated in 1927, the city of Tustin did not experience a major population boom until World War II, when a navy airship base was constructed nearby. Because of the city's relatively small size, the only building to sustain major damage in the 1933 earthquake was Tustin Elementary School. The city was awarded $45,000 from the PWA for reconstruction of the building, which continued to stand until the mid-1960s. The site, which was on C Street near Second Street, is now a senior center.

Santa Ana

Founded in 1869, Santa Ana is both the second-most populous city in Orange County (with almost 330,000 residents) and the county seat. Given its prominence within the county, it comes as no surprise that Santa Ana received quite a bit of federal assistance during the Great Depression. A new city hall, high school, elementary schools and parks all helped to keep the city going in the wake of the destructive 1933 earthquake and devastating floods in the late 1930s.

One of the of the most impressive New Deal buildings in Orange County is undoubtedly Santa Ana's fourth city hall, which was constructed in 1935. As is the case with many public buildings in the area, the city's third city hall (a Mission Revival building constructed on the same site in 1904) was severely damaged in the 1933 Long Beach earthquake. Many prominent business owners, civil servants and other citizens quickly supported the idea of acquiring federal aid for the construction of a new city hall.

However, in the strongly conservative community of Santa Ana, support was by no means unanimous. A bond election in December 1934 passed by a margin of only ninety-three votes; for many, the thought of spending $125,000 on a new structure seemed extravagant in the middle of the Great Depression. During the following months, scandals plagued the construction process. A Santa Ana City Council member, A.F. LeGage, resigned over controversy surrounding the awarding of the building contract; LeGage also led the movement to oppose the city hall, resulting in death threats from citizens.

Due to all of the controversy, the state of California was forced to pass a law stating that the bond election was valid and that federal aid could be sought for the project. The PWA granted $30,000 to the project; the amount of the bond issued by Santa Ana totaled $70,000. By the spring of 1935, the building was well on its way, officially being referred to as PWA Project No. 6597. It opened to the public later that year. The architect for the project was W. Horace Austin.

The former Santa Ana City Hall, which is located on the corner of Third Street and Main Street, is perhaps one of the finest examples of Art Deco architecture in the entire county. Although characteristic of WPA Moderne architecture in many ways, the structure also recalls the zigzag style of architecture of the 1920s. The most prominent features on the building are the two figures flanking either side of the main entrance (and a third towering two stories above them), which are undoubtedly influenced by ancient Mesopotamian architecture. A fourth-floor tower rises from the west side of the building, featuring more of the building's ornate Art Deco detailing. On the building's marble base, a simple engraving reads, "Erected 1935."

The PWA-funded city hall continued to serve Santa Ana until a new building was dedicated on February 9, 1973. Today, the former city hall continues to stand in the heart of Santa Ana's historic downtown as an office building. The striking Art Deco architecture sharply contrasts many of the Spanish Colonial Revival and Beaux Arts buildings surrounding it.

Santa Ana High School, founded in 1889, is the oldest high school (as well as the largest) in Orange County. In its earliest days, it occupied several locations around the city, but its most fondly remembered early home was a large Romanesque building located on Ninth Street between Main and Bush Streets. Built in 1897 and often compared to the Old Orange County Courthouse (built three years later), this structure housed the high school until 1912, at which point it became a junior high school until 1931.

For the 1913 school year, the school changed its name to the Santa Ana Polytechnic High School and moved to its current location at 520 West

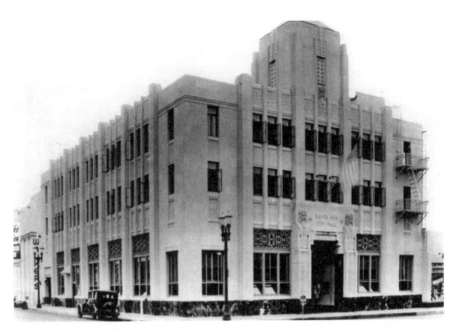

A very controversial New Deal project was the construction of a new city hall in Santa Ana in 1935, with one city council member even receiving death threats. Designed by W. Horace Austin, the structure is a fantastic example of zigzag Art Deco architecture. Since 1973, this building has been used as office space. *Photo courtesy California State Library.*

Walnut Street. As was popular during that time, the $250,000 structure was designed in a Classical Revival style, complete with large columns capped with neoclassical pediments. Although considered the pride of the community, this new structure lasted for only two decades, being irreparably damaged by the 1933 earthquake.

Local residents quickly began acquiring funds to demolish the old buildings and erect a new high school. While the older structure was being demolished, classes were held in the old gymnasium, on the bleachers or—as one student later recollected—in tents set up on the property. By early February 1935, almost a third of $1 million had been acquired through government aid and bond sales (including $100,350 from the PWA). The new buildings were designed by the firm of Allison & Allison, whose portfolio included several other New Deal buildings in Orange County.

Work began in 1935 on the high school's main buildings—a central unit consisting of a theater, study hall, library, auditorium and administrative offices, as well as a science wing and a commerce wing (which has since been demolished). The most expensive by far was the main building, which cost a total of $288,965.

Shown here shortly after its completion is Santa Ana High School, founded in 1889. The New Deal buildings (constructed starting in 1935) were designed by the noted architectural firm of Allison & Allison. Only one building on the school's campus constructed during this time has been demolished. *Photo courtesy University of California.*

With a striking zigzag Art Deco façade that is more highly embellished than many other schools from the WPA era, Allison & Allison's design represents a sharp contrast with the buildings that had previously occupied the site.

Construction did not end in 1935, however, as two additional units for the school were commissioned the following year. Allison & Allison were again hired to design a $95,390, two-story classroom building, as well as a $96,488 manual arts shop, both of which are still standing today. All of the construction was completed in time for the 1937–38 school year, and the New Deal structures have been occupied ever since. Today, Santa Ana High School retains much of its architectural integrity and remains an enduring tribute to Depression-era architecture.

Santa Ana High School was not the only school in the city impacted by the New Deal. While a majority of Santa Ana's elementary schools went unharmed (compared to cities such as Anaheim), at least two were entirely reconstructed or refurbished, with many others being reinforced and repaired. While the two reconstructed schools—Benjamin Franklin Elementary and Thomas Edison Elementary—are still standing, they are also two of the most forgotten New Deal–era landmarks in Orange County.

In late 1933, federal aid was offered to Santa Ana for any necessary reconstruction and refurbishments of public schools. A public vote was set for January 23, 1934, to determine whether the funds were to be accepted; after the date of the vote was shifted to January 19, the Santa Ana Board of Education decided to do away with the vote entirely and accept the federal relief money. Initially, $615,000 was sought from Washington.

Located at 210 West Cubbon Street, Benjamin Franklin Elementary School occupies the site of the former Spurgeon School, named after William Spurgeon, the founder of Santa Ana. Originally housed in a Mission Revival building constructed in the early part of the twentieth century, the Spurgeon School was one of the few in Santa Ana severely damaged by the 1933 earthquake. Following the city's acceptance of federal aid on January 12, 1934, work was quickly begun to demolish the old Spurgeon School and erect a new building on the same site.

The new building, as was customary at the time, was constructed of reinforced poured concrete and features the subtle Art Deco style that was prevalent at the time. Designed by local architect Frederick Eley, the building's main portico features a recessed doorway and a bas-relief figure on either side. Prominent above the school's name is a panel that reads, "1934"—the year of the school's construction. The school remained named after Spurgeon until the mid-1970s, when it sat vacant for a short period. It was subsequently reopened as Benjamin Franklin Elementary School, a name that had previously been used for a different school elsewhere in Santa Ana.

Santa Ana's other New Deal elementary school, Thomas Edison Elementary School, is located at 2063 Orange Avenue. Although Frederick Eley was Orange County's most prominent architect its early years, Franklin and Edison Elementary Schools are the only two of the many schools he designed that are still standing. A beautiful Art Deco façade, featuring energy-inspired reliefs in honor of the school's namesake, graces the exterior of the building. On August 8, 1936, a contract was let for $31,072 for the reconstruction of Edison Elementary School; the building was completed sometime the following year.

Located directly downstream from Orange's Hart Park is Santa Ana's Santiago Park, situated between the 5 and 22 freeways. In the years immediately following the stock market crash, the banks of Santiago Creek became a hobo encampment of out-of-work men. However, following the establishment of a state labor camp in Santa Ana Canyon in 1933, these men were cleared out, and plans for a new park were set in motion.

Originally called the Spurgeon School, Benjamin Franklin Elementary School in Santa Ana was designed by locally significant architect Frederick Eley. The school was constructed following the 1933 earthquake. *Photo courtesy University of California.*

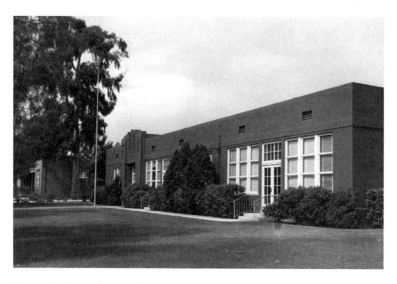

Nearby Benjamin Franklin Elementary School in Santa Ana is Thomas Edison Elementary School, which was built around the same time. Relief images of electrical motifs stand on either side of the façade, honoring the school's namesake. *Photo courtesy University of California.*

Originally, the park was looked at as an extension of Orange's park along the banks of Santiago Creek. Around 1935 or 1936, federal aid (either from the WPA or SERA) resulted in the construction of a lawn bowling green in the park. Further beautification, under park superintendent Dale Griggs, continued in 1937 and 1938, when the park was championed by the *Los Angeles Times* as a "twenty-acre playground." Today, the Depression-era history of Santiago Park is largely forgotten by those who visit.

Compared to the widespread New Deal influence on Hart Park, Santiago Park seems unimpressive; however, it still plays a role in the development of the area, particularly with regard to flood control. As Santiago Creek continues through Santa Ana, many areas feature New Deal–era embankments, and traces of the federal government's involvement can be seen at numerous locations.

A small New Deal improvement that affected Santa Ana was the construction of a foundation beneath the Santa Ana Municipal Bowl, which was financed by the CWA at a cost of $3,563. The same source states that over $15,000 was also spent by the CWA on the construction of a new drill tower for the Santa Ana Fire Department.

Garden Grove

Garden Grove was founded in 1874 as a tiny rural town with little more than a schoolhouse and a church. The coming of the railroads in the early 1900s helped boost the city's growth, and by the 1920s, there were several thousand residents. It was around this time that the city determined the need for a local high school, which was founded in 1921 and moved to its current location at 11271 Stanford Avenue in 1923.

The main building of Garden Grove High School, designed by architect Theodore C. Kistner, was first occupied at the beginning of the fall 1923 semester. Over the next few years, an auditorium and gymnasium were also added to the campus. By the early 1930s, however, the financial situation of the school had taken a turn for the worse, caused primarily by an ever-rising number of students as Garden Grove developed.

However, on the night of March 10, 1933, tragedy struck. Garden Grove was hit particularly hard by the Long Beach earthquake, and much of the city was irreparably damaged. Two local girls had stayed at the high school to prepare for a party that evening; one was killed by a falling brick when

Frederick Eley designed a new building at Garden Grove High School after the former building was destroyed in the 1933 earthquake. Today, this building no longer serves as the main building of the school, although it does house the school's museum and hall of fame. *Photo taken by the author.*

part of the main classroom building collapsed, while the other (the daughter of a local teacher) was seriously injured.

Shortly after the earthquake, the State Division of Architecture determined that the building needed to be demolished to its foundation and rebuilt to stricter building codes. Government workers were used to carry out the demolition job; however, it quickly became apparent how well constructed the original high school building was. Despite using a large iron wrecking ball, some of the walls refused to crumble.

By mid-1934, plans for a replacement school were well underway, with a budget totaling $15,000. Santa Ana architect Frederick Eley was hired to design the building, which features a striking Art Deco façade. Today, Eley's building still stands, although it is no longer the main entrance to the school. Hidden from public view by several newer buildings, the structure is now called Heritage Hall and houses the school's athletic hall of fame and museum.

The only other potential New Deal project in Garden Grove was a proposed post office building, which the U.S. Treasury estimated at a cost of $75,000 on in 1938. However, Garden Grove did not make the final cut of cities that were to receive new post offices at that time.

CHAPTER 5

SOUTHERN AND EASTERN ORANGE COUNTY

Laguna Beach

Although the first permanent homes were built in Laguna Beach in the early 1870s, making it one of Orange County's older communities, the city was primarily a product of the 1920s. Between 1920 and 1930, the population more than quadrupled in size (and again doubled between 1930 and 1940). In 1926, Pacific Coast Highway was completed, and the large influx of people led to the city's incorporation the following year. From its earliest days, Laguna Beach had a reputation as an art colony, filled with painters, writers, filmmakers, sculptors and photographers. The large influx of people—and the new need for infrastructure—provided the perfect opportunity for government funds to be spent as the country tried to pull itself out of the Great Depression.

Prior to 1934, Laguna Beach teenagers had to travel to Tustin each day in order to attend high school. But in the early 1930s, the city decided to establish its own high school district. Only a few years earlier, in 1928, the Laguna Beach Elementary School had constructed a new campus at 625 Park Avenue, including an impressive auditorium; beginning with the 1934–35 school year, the high school took over these buildings.

As soon as the old elementary school was occupied, work was begun to expand the high school campus. In 1936, Allison & Allison were hired to

design a $61,839 gymnasium for the school, and an additional $25,200 was spent on a classroom annex. Both of these projects were funded by an $85,000 bond that was issued on June 28, 1935. Although the high school has continued to add buildings over the decades, both the original 1928 building and the 1936 gymnasium are still standing today.

When the high school took over the elementary school buildings, Laguna Beach Elementary School was forced to move across the street to 670 Park Avenue. By early 1935, construction had begun on the new school, which was estimated to cost $50,000. The architecture is similar in many ways to Newport Beach Grammar School—Art Deco details complement a Spanish Revival building, while a small belfry adds an air of American Colonialism. Like the high school gymnasium, the designers were Allison & Allison. Sometime during the 1980s, the building was reduced in size (although the original façade was maintained), and today it is the entrance to the city's municipal pool.

Only two years after the new elementary school was opened, two additional bond elections were put forward—one for the construction of a new elementary school in the south part of the city, valued at $70,000, and the other for additions to the high school (totaling $30,000). On May 14, 1937, both of these measures were struck down by a narrow margin; both had a majority of the population's support but did not meet the two-thirds majority required. Although the school district continued to look into a second elementary school, it appears that these plans never materialized.

In 1934, when the Public Works of Art Project was established by the federal government, Laguna Beach High School was slated to receive a three-panel mural by local artist Eleanor Colburn, who had moved to Laguna Beach in the early 1920s after studying art in the Midwest. The mural, titled *Background of Abe Lincoln's Youth*, featured three scenes from early in the president's life. The first showed Lincoln at two years old in his mother's arms, the second showed Lincoln splitting rails as a young man and the third depicted Lincoln sitting on a bale of cotton while watching a slave auction.

Oddly enough, although commissioned for the high school, one of the school's administrators was unhappy with the painting, and it was never actually installed. An early version of the mural was exhibited in 1934 at the Los Angeles County Museum, as well as in 1938 at the Laguna Beach Art Association's gallery. Colburn passed away in 1939, but three years later, her daughter donated a painting with the same title to Woodrow Wilson Junior High School in San Diego. Whether this painting was the same as the one intended for Laguna Beach High School is unknown, but regardless, it

Laguna Beach Elementary School occupied this newly constructed building in the mid-1930s, when Laguna Beach High School was opened at the elementary school's former location across the street. Today, portions of the building are used as the entrance to the city's municipal pool.

is extremely unfortunate that Laguna Beach was not the recipient of what sounds like an important piece of New Deal public art.

Controversy surrounded one of Laguna Beach's lesser-known PWA projects. In 1937, the PWA allotted $59,000 for the construction of the Laguna Canyon storm drain, which would have cost upward of $146,000 when finished. However, the offer was revoked the following year, and an investigation was opened by Interior Secretary Harold L. Ickes after concerns of suspicious activity arose. Allegedly, Glenn E. Miller, a lobbyist hired by the county, had accepted a $1,000 bribe in order to secure the grant. It appears that this incident put an end to storm drain talks in the 1930s, although in more recent decades, such infrastructure has been added.

In 1938, the U.S. Treasury Department financed the construction of a new $80,000 post office at 298 Broadway. The small, Mediterranean building served as a post office for only a few years due to a bad location and access problems for locals. The building was ultimately converted to retail space and continues to stand today.

Not all of Laguna Beach's proposed public works projects were actually undertaken during this time period. One notable example was the proposition to construct a new municipal pier off the coast, as was being

done in Huntington Beach and Seal Beach. In 1935, a $55,000 bond election was put up for a vote among the city's citizens; such a bond would ensure $45,000 of PWA money to complete the task. The proposal was overwhelmingly defeated, however, by a vote of 183 yeses versus 313 nos.

SAN JUAN CAPISTRANO

Although best known for its Spanish Mission, San Juan Capistrano features a very diverse and varied history over the past several hundred years. During the New Deal, several projects were undertaken by agencies such as the WPA, PWA and CCC.

Located at 31422 Camino Capistrano in San Juan Capistrano, Junipero Serra High School currently serves as an alternative education school; however, the school (which was formerly known as San Juan Capistrano Union High School) is one of the most historic schools in south Orange County. The city of San Juan Capistrano founded a high school district in 1919 and purchased ten acres of land the following year.

Over the next few years, several Spanish Colonial Revival buildings were constructed on the site. The school served not only San Juan Capistrano but also the neighboring communities of San Clemente, Serra, Doheny Palisades and Dana Point. Due to the growth of south Orange County in the 1920s and '30s, it was decided in 1938 that an expansion to the high school was necessary.

Acquiring funds for the new school buildings, however, was not an easy task. The first attempt was made in April 1938, when a plan was put forth for $290,000 worth of improvements—$160,000 of which would be acquired through bonds and $130,000 provided by the PWA. For this cost, two new buildings and an athletic field would be constructed. On May 20, this measure was struck down overwhelmingly by voters.

That July, the school board revised the total cost to $118,000, again having 55 percent ($65,000) funded by bonds and the remaining 45 percent provided via a PWA grant. Although this vote got a slight majority of the public's support, it did not meet the required two-thirds majority and was likewise struck down.

In a desperate last attempt to raise money, the high school district cut the amount of bonds being sold to $45,000; voters supported this measure by a

Serra High School, formerly San Juan Capistrano High School, features an administration building that was constructed in 1939. Although designed in a Streamline Moderne style, it blends in with the city's widespread Spanish Colonial Revival architecture. *Photo taken by the author.*

margin of four to one. In fulfillment of the standard arrangement, the PWA provided an additional $36,800 for the school's expansion. Plans were drawn up by Theodore C. Kistner, an architect who designed other local projects such as Brea Grammar School and Anaheim High School.

Construction on both an athletic field and a new wing of the high school were begun shortly thereafter, and the projects were completed in 1939. By the late 1950s, many of the high school's original 1920s buildings were deemed structurally unsound and were demolished shortly thereafter. The New Deal–era wing, having been built to more recent earthquake standards, was left untouched.

Today, the 1938–39 wing of Junipero Serra High School is one of the finest local examples of Streamline Moderne architecture, a style that was never extremely popular in Orange County. The curved corners near the front entrance of the school are very typical of late 1930s architecture. Additionally, many fine details are evidence of the workmanship that went into the school—an impressive bas-relief of Father Junipero Serra stands over the main entrance, and some of the building's walls were originally

Stone Field, in San Juan Capistrano, features extensive stonework that dates to the New Deal. It is very similar to other parks from this era, including Hillcrest Park in Fullerton and Hart Park in Orange. The stonework continues around adjacent Serra High School, which was constructed at the same time. *Photo taken by the author.*

A little-known New Deal building in Orange County is the former San Juan Capistrano fire station, which features a WPA plaque on its exterior. *Photo taken by the author.*

constructed of glass blocks instead of windows. These blocks have since been covered in stucco, slightly compromising the building's architectural integrity.

Adjacent to Junipero Serra High School is Stone Field, a large recreational park that gets its name from the numerous structures built of locally quarried stone. Built at the same time as the high school, Stone Field is one of the most impressive New Deal landmarks in all of Orange County. Over the years, Stone Field has been the home of baseball, soccer and football games and even bonfires for local high school students.

A large wall, made of rough-hewn rock, runs around the perimeter of Stone Field. The park's architecture is part of a movement historians have titled "WPA Rustic" or "National Park Service Rustic." Similar construction is seen in other local parks, such as Amerige Park in Fullerton and Hart Park in Orange. In addition to the park's main wall, which continues to run through the Junipero Serra High School campus (unifying the two New Deal projects), there is also an archway, a staircase and a large set of bleachers made of the same type of stone.

Located only a few blocks from the high school is San Juan Capistrano's historic fire station complex (31411 La Matanza Street). Information regarding these buildings is incredibly hard to come by; there is evidence to suggest that CCC workers from Camp Trabuco helped to construct a fire station in San Juan Capistrano, although the specifics of what these men did is unknown. What is known is that one of the buildings in the complex, now called the Tony Nydegger Building, contains a bronze plaque that reads, "BUILT BY UNITED STATES WORK PROJECTS ADMINISTRATION 1940." The building, a large brick recreational hall, is now used by the local American Legion post.

SILVERADO

The small town of Silverado is tucked away in the Santa Ana Mountains, seemingly cut off from the rest of Orange County. It's remoteness, however, didn't prevent it from being a recipient of New Deal aid. Silverado Elementary School was first established in 1881, and by 1903, it occupied a one-room schoolhouse. Over the following years, additional buildings were added, but the most major change came in the form of WPA aid during the mid-1930s. The WPA expanded and renovated the school while at the same

time adding a Mission Revival–style façade. This building was demolished in 1957, when the modern school was constructed on the same site.

Civilian Conservation Corps

The Civilian Conservation Corps, one of the first New Deal Agencies founded in 1933, had a profound impact on California. Within the first year, California alone had no fewer than 128 different camps, and over the next decade, dozens of state parks, national parks, national forests and other wilderness areas were improved by the program. At the time, Orange County had only a couple state parks and Cleveland National Forest, so CCC aid wasn't nearly as widespread as other government agencies, however, the Corps still left its mark in certain places around the county.

On May 30, 1933, the first CCC camp in Orange County was established. Company 545 was assigned to San Juan Capistrano, bearing the project number P-228 (the "P" represents the fact that its work was done on a privately owned forest). This camp was replaced on April 23, 1934, by Company 912. CCC workers in San Juan Capistrano seem to have helped

A photograph of the Civilian Conservation Corps Company 912, or Camp Trabuco, which was located in El Toro. The photograph was taken in December 1933, only a few months after the CCC was established. *Photo courtesy Orange County Archives*.

construct the city's fire station (also a WPA project), although further details about their involvement in the area are largely unknown.

Perhaps the most CCC work in the area was done along the southern coast of Orange County, at Doheny State Beach and San Clemente State Beach. The last company to be brought to Orange County was Company 916 on October 17, 1939. This company had formerly worked in Yosemite and Sequoia National Parks before being transferred to San Clemente. Once in Orange County, their project was titled SP-27, designating it as a state park improvement.

Doheny State Beach was acquired by the state in 1931 as a gift from oil magnate Edward L. Doheny. San Clemente State Beach was purchased by the state that same year for $400,000 and was dedicated on June 30, 1933. When President Roosevelt visited San Clemente State Beach in July 1938, he said it was "one of the most beautiful spots [he'd] ever seen."

As soon as Company 916 arrived, it began working on improving both state beaches for recreation purposes. The three hundred men in the company camped at San Clemente State Beach and either worked there or traveled to Doheny each day. At San Clemente, the CCC workers constructed campgrounds, and evidence of their work can still be found in the form of stone gutters throughout the park. They also built an office, three residences, a blacksmith shop and a garage, although it is unknown whether any of these structures still exist.

At Doheny State Beach, CCC workers constructed picnic areas, parking lots, campgrounds and a custodian's lodge, although all of these features have since been removed. The only two remnants of the CCC's labor are a tiled, adobe archway that sits along Pacific Coast Highway and a rock formation known as "Thor's Hammer" that sits at the park's breakwater. By mid-1940, when work at the parks was done, the company was reassigned to Sacramento.

CCC camps also existed elsewhere in the county. Company 912 was moved from San Juan Capistrano to Camp El Toro on May 30, 1935. Known as project P-364 (again, working on a private forest), this camp was located approximately where the Trabuco School is today and was alternately known as Camp Trabuco. In nearby Silverado, Company 546 was assigned to project F-116 on June 2, 1933. The "F" in its name designates that Company 546 was assigned to a national forest—namely, Cleveland National Forest.

As is the case with south Orange County, specifics regarding the El Toro and Silverado Camps' work are hard to come by. It is know that during the 1930s, CCC workers in the area constructed a ranger station at Silverado, as well as lookout stations on Santa Margarita and Santiago Peaks (the latter of which is the tallest mountain in Orange County). Other men were tasked with building dams in Silverado Canyon, erecting telephone lines and creating firebreaks. A vast majority of the time, the CCC's efforts went largely unnoticed by the press. One major exception was an instance on December 5, 1933, when a Silverado Camp worker was killed after his truck overturned.

Today, the effects of the CCC's work in Orange County are not as visible as the work of the WPA or Federal Art Project, but that does not mean the agency was any less important. Undoubtedly, much of the infrastructure and trails in the county's forests and mountains today is a direct result of the hundreds of young men who worked to improve the area's natural resources.

CHAPTER 6

OTHER NEW DEAL PROJECTS IN ORANGE COUNTY

Not all of the work that was done by the New Deal in Orange County consisted of construction projects. President Roosevelt was clear with his goals to provide jobs for everybody affected by the Great Depression—not just laborers. Different programs he created also sought to provide relief for out-of-work writers, architects, scientists and other specialty occupations; there were also jobs offered for women who had never worked before the tough economic times forced them to.

Given that Santa Ana serves as the county seat, it should come as no surprise that much of Orange County's WPA infrastructure was based there. As will be seen in the following sections, the WPA did much more than simply provide labor-based jobs to out-of-work men. The organization also sought to provide service-based jobs for women, provide food and shelter for needy families and establish nursery schools for young children.

Women were provided numerous opportunities to work under the WPA, including several programs in Orange County. By the late 1930s, a WPA-funded nursery school had been formed at Santa Ana's Hoover School, and in 1942, a second nursery was located at 610 Garfield Street. Not only did these establishments provide care for young children in poor areas, they also allowed women to work for the government and help to provide for their families. Another program implemented by the WPA was providing school lunches in many parts of the country.

Also in Santa Ana, where the WPA's local administrative offices were located, artists worked to create exhibits for the local Bowers Museum.

A food distribution center was also established in the city, providing local unemployed residents with free food for their families.

Federal Project Number One

A group of five WPA projects focused on the arts and history was collectively called Federal Project Number One. Unlike the facet of the WPA that was aimed at providing manual labor jobs, Federal Project Number One was designed to employ artists, writers, musicians, actors and historians while at the same time helping to boost the public's morale by providing them with public artwork, concerts, plays and books.

The first of these projects, the Federal Art Project, has already been covered in the previous chapters of this book. The FAP served as a replacement for the Public Works of Art Project, which was administered by the U.S. Treasury. It's work in Orange County included projects such as Newport Harbor High School's two large mosaics, Newport Beach Elementary School's two murals and Fullerton City Hall's mural, to name a few.

Some of the Southern California division of the FAP's most prestigious artists worked in Orange County during this time, including Arthur Ames, Jean Goodwin and Helen Lundeberg—all of whom created other pieces of public art throughout the state during this time. As politically controversial as the New Deal was, the FAP (along with the other Federal Project Number One programs) was widely celebrated by the public due to its very visible products and relatively low cost.

Just as the Federal Art Project employed out-of-work artists during the Great Depression, the Federal Writers' Project sought to provide work for writers who were struggling during the 1930s. The most famous publications of the FWP are the books in the American Guide Series, a series chronicling the history and culture of each of the forty-eight states at that time (plus other territories, cities and regions). Although there were no books published specifically about Orange County, the book *California: A Guide to the Golden State*, published in 1939, does feature a good deal of information about the county during the New Deal years.

The last section of the book is a series of driving tours throughout the state. Over the course of these tours, nearly every city and town in the state is briefly described. Several New Deal projects, including Hillcrest Park,

An advertisement for the Federal Writers' Project's *Guide to the Golden State*, a guidebook to the state of California published in 1939. Although no books were written specifically about Orange County, this statewide guide contains passages about the county that give the reader a snapshot of local life in the late 1930s.

Commonwealth (now Amerige Park) and Anaheim's Modjeska statue, are mentioned by name—an easy way for the FWP to promote other tenants of the New Deal. It is also interesting to note that several communities that no longer exist—including Red Hill, Atwood and El Modena—are included among Orange County's cities.

Although it is unfortunate that Orange County did not warrant an entire publication by the FWP, such as Los Angeles and San Diego did, the relevant sections in the American Guide Series book on California nevertheless provide a very important snapshot of what it would have been like to visit Orange County at the time that many of the New Deal projects in this book were being worked on. The Historical Records Survey, another of the five Federal Project Number One programs, was originally part of the FWP before branching off.

Another program that was part of Federal Project Number One was the Federal Theater Project, which, at its peak, employed 12,700 people across

Left: A very rare example of a WPA poster from Orange County, this piece advertises a production put on by the WPA's Federal Theater Project at Santa Ana High School. The Federal Art Project, responsible for producing such posters, is one of the most fondly remembered tenants of the New Deal. *Photo courtesy Library of Congress.*

Opposite: Like the poster from Santa Ana High School, this WPA-designed poster advertises Myra Kinch's *Festival of Modern Dance*. Productions such as this one were put on by the Federal Theater Project and would travel to various cities in order to expose as many people as possible to the arts. *Photo courtesy Library of Congress.*

the country. Although the New York City division was the most prolific, there were also a large number of plays staged by the Pacific Southwest region, of which Orange County was a part.

Finding information about specific productions is very difficult, especially for somewhere like Orange County, which was not a major market. However, the fact that the FAP designed posters for FTP productions helped to ensure that information about certain productions exists. The only known FTP posters that still exist from Orange County are both for Myra Kinch's *Festival of Modern Dance*. Myra Kinch, a well-known dancer and choreographer, served as the director of the West Coast Dance Project of the FTP.

Festival of Modern Dance first appeared in Orange County on Saturday, October 16, 1937, at the Laguna Beach High School auditorium and featured twenty-three dancers performing a number of routines. The show returned to Orange County on Monday, March 21, 1938, when it played at the Santa Ana High School auditorium. Ticket prices ranged from $0.25 to $1.10. With these two exceptions, however, it is unknown what other plays were put on in Orange County by the project.

Similar to the Federal Theater Project was the Federal Music Project, which sponsored concerts, operas, music research programs and orchestras throughout the country. As is the case with the FTP, very little information survives regarding

This poster, advertising *The Chocolate Soldier* at Santa Ana High School, shows that the operetta was put on by the Federal Music Project. Like the Federal Theater Project, the Federal Music Project sought to put on concerts, operas and other performances in smaller cities that did not typically have big musical productions come through. *Photo courtesy Library of Congress.*

the program's influence at the local level in Orange County. One exception is an FAP-designed poster for a production of the operetta *The Chocolate Soldier* at the Santa Ana High School auditorium in the late 1930s. This production was put on by the Los Angeles division of the FMP.

There are also several references to federal marching bands playing at various civic events throughout the county during the 1930s, although their exact relationship with the FMP is unknown. Presumably, they were among the many marching bands organized by the project around the country. An FMP regional office was also established in Santa Ana. One other interesting historic anecdote recounts that FMP musicians would regularly visit Orange County schools dressed as cowboys to perform traditional western ballads.

HISTORIC AMERICAN BUILDINGS SURVEY

By the 1930s, historic preservation was still an up-and-coming discipline. On November 13, 1933, Charles E. Peterson, who worked for the National Park Service, wrote a memo to the service's director about the creation of a program to document and preserve historic buildings. Peterson was able to acquire funding from the CWA to start

Other New Deal Projects in Orange County

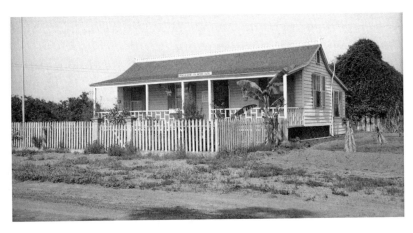

This photograph of the Mother Colony House in Anaheim was taken in 1934 by the Historic American Buildings Survey. The HABS was aimed at documenting locally significant buildings around the country by extensively photographing and drawing them. *Photo courtesy Library of Congress.*

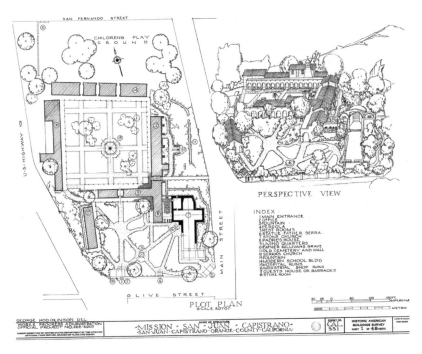

This graphic was produced by the WPA in the mid-1930s as part of the HABS, which was designed to document and preserve historically significant structures. As part of the program, Mission San Juan Capistrano was extensively drawn and photographed by WPA workers. *Photo courtesy Library of Congress.*

such a program, and today he is commonly referred to as the "godfather of preservation."

The program that Peterson founded was called the Historic American Buildings Survey (HABS), which began its work in January 1934. Throughout the country, unemployed architects, draftsmen and photographers were tasked with measuring, drawing and recording information about buildings that contributed to the history of the United States in a significant way.

Several buildings in Orange County were catalogued by the HABS. In Anaheim, two houses dating to the city's earliest days were included in the survey. The Sheffield House, located at the northwest corner of Anaheim Boulevard and Sycamore Street, was constructed in 1886 and is no longer standing. The HABS drawings and photographs of the house provide the only sources of information about this house, which has largely been forgotten since its demolition in the 1960s.

Also documented by the HABS was the Pioneer House of the Mother Colony, which was the first house in Anaheim. Constructed in 1857 by George Hanson, the house was originally located at Anaheim Boulevard and Cypress Street but was moved to its current location at 414 North West Street in 1929. Documenting both of these residences took place in March 1934, while the project was still in its infancy. It is very interesting that the federal government found these two houses important enough to include in its nationwide survey of historic architecture.

Several years later, Mission San Juan Capistrano was also included in the survey. Drawings and photographs were made in 1936 and 1937, by which point the WPA had become involved in the HABS. Many detailed maps and diagrams of the mission, all of which demonstrate a high level of artistic ability, were created as part of the project by WPA artists. Today, this historic value of these documents is twofold—in addition to providing modern historians with information about the Spanish mission, they also serve as unique pieces of New Deal artwork.

WPA Archeological and Historical Programs

One of the most widespread WPA programs in Orange County was a historical and cultural survey of the county. Primarily, the work was focused on documenting the Native American and Spanish Colonial history of the

Other New Deal Projects in Orange County

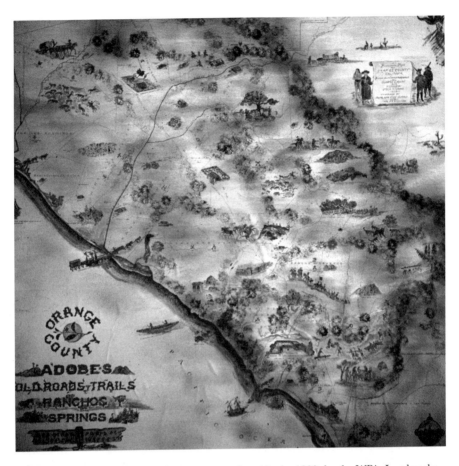

This whimsical map of Orange County was produced in the 1930s by the WPA. Landmarks from Orange County's earliest days are shown—many of which were excavated by archeological programs funded by the WPA. Producing artwork such as this was almost as fundamental to the program as its construction programs. *Photo courtesy Orange County Archives.*

county, and the program's reports include topics such as food, government, education, industry and religious customs of the county's earliest days. Many of these resources are still used by historians today due to the sheer volume of information that was gathered together for the first time. These publications helped to provide jobs for local writers and historians who were out of work during the Depression.

This program also included a series of archeological and anthropological excavations conducted at various sites. Although the WPA's findings are far too extensive to be covered adequately in this book, it is still interesting to

note the locations at which the program excavated. Some of the earliest excavations also featured assistance from SERA.

The earliest sites where excavations were begun soon after the WPA's creation in 1935 included Limestone Canyon (which is now a regional park), the land surrounding the Newland House in Huntington Beach, the former Banning Estate in Costa Mesa, the former town of Fairview (near the intersection of Adams Avenue and Fairview Road) and a site called Sand Hill Camp.

The following year, an excavation at Moro Canyon (now part of Crystal Cove State Park) was conducted, while in 1937, the WPA excavated Black Star Canyon (near the town of Silverado) and Santiago Cave. The last years of the project saw work being done at several locations in the San Joaquin Hills, Corona Del Mar, Bonita Mesa and Griset. Today, all of the WPA's original reports reside in the Special Collections of the University of California, Irvine. The archaeological artifacts that were uncovered during this time are still being studied by scientists today, showing how important the anthropological work done by the WPA was.

Infrastructure

The main body of this book examines the major construction projects that were undertaken in Orange County during the New Deal. The projects covered are primarily public buildings that are very visible and accessible. However, not all of the construction work done during the New Deal consisted was related to public buildings. Infrastructure such as sewers, waterworks systems, roads and flood control channels were also added during this time. Nearly every major city in Orange County received a new sewage treatment plant or sewer system under the New Deal. Very few of these structures still stand today, and since most of the infrastructure they provided was underground and invisible to the general public, they'll only be covered very briefly here. A few cities such as Seal Beach and Laguna Beach are covered in some detail because they are blueprints for the process that other cities went through in acquiring funding for sewage systems.

On December 13, 1934, plans were prepared for the "Seal Beach Sewage Treatment Plan and Outfall Sewer." The Public Works Administration approved the plan, officially called PWA Project No. 8839, and allocated

Other New Deal Projects in Orange County

Designed in a Mediterranean style, the Laguna Beach sewage treatment plant is unique in that it is the only such structure in the county that was preserved due to its historical and architectural significance. Today, it is located in the middle of a parking lot but, fortunately, has historic landmark status within the city. *Photo taken by the author.*

$52,000 to the city. Meanwhile, the city itself issued $40,000 worth of bonds in order to construct additional sewers throughout the city after the citizens had voted 358–32 to support the measure. The Seal Beach sewage disposal plant was located in the northwest part of the city, on Electric Avenue between First Street and Corsair Way, and while in operation served the community of Sunset Beach as well. Aerial photographs show that the facility was still standing as recently as 1972; however, the site is now part of a housing tract.

Meanwhile, in Huntington Beach, storm drains were installed in many locations, including one at Orange Avenue and Thirteenth Street in 1937 at a cost of $16,000. Another major project undertaken in 1936 was the construction of an $82,000 sewage treatment plant, similar to the ones found in other cities along the coast. While not as visible as the downtown post office or municipal pier, improvements such as these were no less important in providing the growing city with the necessary infrastructure.

Like other local communities, Newport Beach also received PWA funding for a sewage disposal plant. The complex was completed in 1937 at a cost of $359,472; it is currently believed that these buildings are no longer standing.

Sunset Beach also received a sewage treatment system, located near Los Patos Avenue in Huntington Beach. Many inland cities also constructed sewage treatment systems, although none are still operating, and detailing all of them is beyond the scope of this book.

The most interesting sewage treatment plant in the county, from an architectural and historical standpoint, is Laguna Beach's. What sets Laguna Beach's apart is the artistic design of the main buildings, as well as the fact that the remaining structures are recognized as local historic landmarks. Construction of the plant began in early 1934 after a combination of PWA funds, CWA aid and a local bond election had raised a total of $180,000. Between 200 and 250 men were employed by the project, which took about six months to complete.

While additional sewers and pipelines were added to the city's sewage system over the next few years, the heart of the project were the main treatment buildings, located on Laguna Canyon Road north of Forest Avenue. Even contemporary sources noted that the buildings were a "departure in design of a [typical] treatment plant." The complex was designed in a unique Mediterranean style, the main building (resembling a grain silo) being topped with a red tile roof. What is even more impressive is that long after these buildings outlived their usefulness, portions of them were left standing in a parking lot, even being listed by the city of Laguna Beach as historic landmarks. Today, although altered considerably since they were constructed, they remain a unique part of the New Deal's story in Orange County.

The devastating floods in 1937 and 1938 also saw the implementation of many flood control measures during the New Deal. By the mid-1930s, a vehement battle was raging over the issuance of a $6,620,000 bond in Orange County for the purpose of a flood control project; this bond was just part of the total project, which was estimated to cost $12,994,000. The main issue of the argument hinged on the fact that most of the work proposed was to be done in San Bernardino and Riverside Counties, with very few jobs being created in Orange County. Eventually, infrastructure was put into place in the form of dams (such as the Prado Dam, in Riverside County), as well as the channelization of the Santa Ana River (as has been covered in previous chapters). Due to the infrastructure now in place (and the lack of agriculture today), the county will never experience another flood as devastating as the one in 1938.

APPENDIX

Orange County's Most Important Pieces of New Deal Art and Architecture

AMERIGE PARK
300 East Commonwealth Avenue
Fullerton, CA 92832
Constructed: 1934
The stone pilasters that surround the outfield of the baseball field were constructed by New Deal workers. A grandstand that was built at the same time was destroyed in a fire.

ANAHEIM HIGH SCHOOL
811 West Lincoln Avenue
Anaheim, CA 92805
Constructed: 1934–37
Architect: T.C. Kistner
Anaheim High School still features an auditorium, gymnasium and classroom building constructed during the New Deal. These Art Deco buildings replaced a Classical Revival campus that was destroyed in the 1933 earthquake. A cornerstone on the main building commemorates the PWA money that went toward reconstructing the school.

Appendix

Anaheim Library Murals
500 West Broadway and 241 South Anaheim Boulevard
Anaheim, CA 92805
Created: 1934
Artist: Arthur Ames
Originally located at Anaheim's Carnegie library, these murals were moved in the 1960s when the library was relocated. The two smaller pieces are currently not on display at the Anaheim Library Central Branch due to vandalism, but there is talk of restoration efforts. The central panel is hanging at the Anaheim Heritage Center Disney Resort Reading Room.

Benjamin Franklin Elementary School
521 West Water Street
Anaheim, CA 92805
Constructed: 1938–39
Architects: Marsh, Smith and Powell
Out of all of the elementary schools that were constructed during the New Deal in Anaheim, Benjamin Franklin Elementary School is the only one still standing. Although not as impressive as many of the county's other schools from this era, the Streamline design is unique to this period.

Brea Junior High School
400 North Brea Boulevard
Brea, CA 92821
Constructed: 1935–36
Architect: T.C. Kistner
Originally Brea Grammar School, this building was extensively remodeled to comply with safety standards imposed after the 1933 earthquake.

Cypress Elementary School
5202 Lincoln Avenue
Cypress, CA 90630
Constructed: 1936
Architects: W. Horace Austin and Harold C. Wildman
Now a church, this former elementary school (which dates back to the turn of the twentieth century) was improved during the New Deal. The school's auditorium is now used as a chapel.

Appendix

Doheny State Beach
25300 Dana Point Harbor Drive
Dana Point, CA 92629
Constructed: 1939–40

CCC workers from San Clemente constructed several buildings at Doheny State Beach, although the only infrastructure that survives today is an adobe arch along Pacific Coast Highway and a rock formation known as "Thor's Hammer."

Dwyer Middle School
1502 Palm Avenue
Huntington Beach, CA 92648
Constructed 1933–35
Architects: Allison & Allison

Originally hailed as one of the most beautiful schools in the state when it was completed, Dwyer Middle School represents one of Huntington Beach's few remaining New Deal structures. A bronze plaque commemorates the school's dedication.

Fullerton City Hall
(now Fullerton Police Department) and mural
237 West Commonwealth Avenue
Fullerton, CA 92832
Constructed: 1939–42
Architect: George Stanley Wilson
Mural created: 1941
Artist: Helen Lundeberg

Fullerton's impressive city hall is one of the largest New Deal structures in Orange County. Since 1963, the building has served as the city's police headquarters. In what was formerly the city council chambers, a three-panel mural by Helen Lundeberg, titled The History of Southern California, was restored to its original appearance in the early 1990s.

Fullerton College
321 East Chapman Avenue
Fullerton, CA 92832
Constructed: 1934–40
Architect: Harry K. Vaughn

Fullerton College, which is the oldest continuously operating community college in the country, features several New Deal structures, including the Commerce Building and Administration Building. Architect Harry K. Vaughn modeled the college's campus after Thomas Jefferson's University of Virginia.

Appendix

Fullerton Library (now Fullerton Museum Center)
301 North Pomona Avenue
Fullerton, CA 92832
Constructed: 1941–42
Architect: Harry K. Vaughn
Now used as the Fullerton Museum, this library building was built to replace the former library funded by Andrew Carnegie. A WPA project, this is one of the latest New Deal buildings in Orange County (construction was completed even after the United States entered World War II).

Fullerton Post Office and Mural
202 East Commonwealth Avenue
Fullerton, CA 92832
Constructed: 1939
Supervising Architect: Louis A. Simon
Mural Created: 1942
Artist: Paul Julian
Fullerton's post office, one of only three from this era that are still operating, features a mural commissioned by the Treasury Department Section of Fine Arts. Orange Pickers, *by Paul Julian, depicts the agricultural economy on which much of Orange County was based. The post office was listed on the National Register of Historic Places in 2012.*

Garden Grove High School
11271 Stanford Avenue
Garden Grove, CA 92840
Constructed: 1934
Architect: Frederick Eley
Now called Heritage Hall, the New Deal building of Garden Grove High School houses a museum and sports hall of fame. Although formerly the front of the school, construction over the years has blocked the building from street view.

Helena Modjeska Statue (in Pearson Park)
400 North Harbor Boulevard
Anaheim, CA 92805
Created: 1934–35
Artist: Eugene Maier-Krieg
Honoring one of Orange County's most famous residents, this larger-than-life statue depicts famed actress Helena Modjeska as Mary, Queen of Scots. This was one of Orange County's first pieces of public art during the New Deal.

Appendix

Hillcrest Park
1200 North Harbor Boulevard
Fullerton, CA 92832
Constructed: 1933–37
Hillcrest Park features extensive stonework installed by the WPA and other New Deal agencies—examples include numerous staircases, retaining walls and picnic areas. A large fountain once existed in the park, although today the base has been turned into a planter. The park has been a federally listed landmark since 2004.

Huntington Beach High School Industrial Arts Building
1905 Main Street
Huntington Beach, CA 92648
Constructed: 1937–38
Architects: Allison & Allison
While the famed auditorium at Huntington Beach High School was designed by Allison & Allison in 1926, the architectural duo returned in the 1930s to design an industrial arts building that is still standing today.

Huntington Beach Municipal Pier
Pacific Coast Highway and Main Street
Huntington Beach, CA 92648
Constructed: 1939–40
Although more recent storms have caused the pier to be rebuilt several times since the New Deal, the structure still retains much of its architectural integrity from the era. The pier is currently listed on the National Register of Historic Places.

Huntington Beach Post Office
316 Olive Avenue
Huntington Beach, CA 92648
Constructed: 1934–35
Supervising Architect: Louis A. Simon
One of only a couple New Deal post offices still remaining in Orange County, the Huntington Beach Post Office has survived demolition over the years, unlike the fire station, municipal hall and city hall nearby. A display inside shows photos from the building's dedication.

Appendix

IRVINE REGIONAL PARK
1 Irvine Park Road
Orange, CA 92869
Constructed: 1935–36
Orange County's first regional park features stonework fireplaces, sinks and barbecues constructed by the WPA. At each picnic area, a plaque commemorates the WPA's involvement.

LAGUNA BEACH ELEMENTARY SCHOOL
670 Park Avenue
Laguna Beach, CA 92651
Constructed: 1935
Architects: Allison & Allison
When Laguna Beach High School was established and took over the elementary school's campus, Allison & Allison designed the new elementary school across the street. Today, this building serves as the entrance to the city's municipal pool.

LAGUNA BEACH HIGH SCHOOL GYMNASIUM
625 Park Avenue
Laguna Beach, CA 92651
Constructed: 1936
Architects: Allison & Allison
The only New Deal building surviving on Laguna Beach High School's campus is the gymnasium, which Allison & Allison designed in 1936. Other historic buildings on the campus from the 1920s were once home to the city's elementary school.

LAGUNA BEACH POST OFFICE
298 Broadway
Laguna Beach, CA 92651
Constructed: 1938
Built by the U.S. Treasury Department, this building served as a post office for only a few years before being closed due to a poor location. Today, it serves as retail space.

LA HABRA LIBRARY (NOW LA HABRA HISTORICAL MUSEUM)
215 East La Habra Boulevard
La Habra, CA 90631
Constructed: 1935–37
Part of La Habra's original civic center, the old library building (and the Veterans' Memorial Hall next door) are the only historic buildings that survive.

Appendix

Lake Park Recreation Building
Lake Street and Twelfth Street
Huntington Beach, CA 92648
Constructed: 1937–38
Although one of Orange County's smaller New Deal buildings, the recreation building at Lake Park represents an important piece of local history.

La Palma Park
1151 North Anaheim Boulevard
Anaheim, CA 92801
Constructed: 1937–39
This park, funded by the WPA, features a large baseball field that, for many years, was used by the Pacific Coast League. Most of the park's palm trees were over fifty years old when they were planted in the 1930s. A parking lot occupies the former site of a lily pond.

Laurel Elementary School
200 South Flower Avenue
Brea, CA 92821
Constructed: 1938
As was the case with Brea Junior High School, this building was remodeled to its modern appearance after the 1933 earthquake.

Loara Elementary School
1601 West Broadway
Anaheim, CA 92805
Constructed: 1935–36
Architect: Richard M. Bates Jr.
At the time this school was reconstructed following the earthquake, Loara was its own independent community with its own school district. Outside the school, the bell from the original 1888 schoolhouse is mounted with a plaque.

Maple Elementary School
244 East Valencia Drive
Fullerton, CA 92832
Constructed: 1935–36
Architect: Everett E. Parks
A simple, vaguely Art Deco building, Maple Elementary School is one of the few buildings still standing from Fullerton's citywide school construction project in the wake of the 1933 earthquake.

Appendix

Newport Beach Elementary School and Murals
1327 West Balboa Boulevard
Newport Beach, CA 92661
Constructed: 1935
Architect: D.B. Kirby
Murals Created: 1937
Artist: Jaine Ahring
Newport Beach Elementary School was constructed to replace a brick structure that had been destroyed by the 1933 earthquake. In 1937, Jaine Ahring painted two murals (Alice in Wonderland and Mother Goose) under the FAP; both are still hanging within the school.

Newport Harbor High School Mosaics
600 Irvine Avenue
Newport Beach, CA 92663
Created: 1935
Artists: Arthur Ames and Jean Goodwin
Although Newport Harbor High School was constructed before the New Deal, the school is home to two large mosaics created by Arthur Ames and Jean Goodwin as part of the FAP. Three Fisherman and Three Women Gathering at the Sea Shore have recently been relocated to the school's reconstructed Robins Hall.

Newport Harbor Improvements Plaque
Channel Road and East Ocean Front
Newport Beach, CA 92661
Constructed: 1934–36
This plaque, erected shortly after the completion of Newport Harbor's dredging, celebrates local resident George A. Rogers's integral role in the harbor improvement project. At $1.8 million, it was the most expensive New Deal project in Orange County.

Olive Civic Center
3030 North Magnolia Avenue
Orange, CA 92865
Constructed: 1937–39
Architect: Fay R. Spangler
Originally located in the community of Olive, this building was constructed by the WPA as part of the local elementary school. The original school has since been torn down, although this Spanish Colonial Revival building still remains.

Appendix

Orange City Park (now W.O. Hart Park)
701 South Glassell Street
Orange, CA 92866
Constructed: 1934–40

Hart Park, located along Santiago Creek, is home to several features constructed by New Deal laborers. A swimming pool and band shell are both from the era, as are the rock walls lining the creek. A stone pilaster in the park makes reference to the WPA's involvement.

Orange Post Office
308 West Chapman Avenue
Orange, CA 92856
Constructed: 1935
Supervising Architect: Louis A. Simon

Along with Huntington Beach and Fullerton, this is one of three operating New Deal post offices in Orange County. In recent years, the post office has been threatened with closure due to budget cuts, but it appears to be safe for the time being.

Placentia City Hall
110 South Bradford Avenue
Placentia, CA 92870
Constructed: 1940
Architects: W. Horace Austin and Harold C. Wildman

One of Orange County's forgotten New Deal landmarks, this building served as Placentia's city hall, jail and fire department from 1940 until 1974. Today, the building is used as retail space and is listed as a city historic landmark.

Plummer Auditorium mural
201 East Chapman Avenue
Fullerton, CA 92832
Created: 1934
Artist: Charles Kassler Jr.

Like Newport Harbor High School, Plummer Auditorium (part of Fullerton High School) was constructed in the years leading up to the New Deal. However, in 1934, the PWAP commissioned Charles Kassler Jr. to paint a seventy-five- by fifteen-foot fresco on the side of the building. Pastoral California was covered for most of its history before being refurbished in 1997.

Appendix

SAN CLEMENTE STATE BEACH
225 Avenida Califia
San Clemente, CA 92672
Constructed: 1939–40
CCC workers helped to construct the campgrounds and several structures at San Clemente State Beach. Workers actually camped at this beach and would commute to Doheny State Beach to work as well.

SAN JUAN CAPISTRANO FIRE STATION
31411 La Matanza Street
San Juan Capistrano, CA 92675
Constructed: 1940
Very little is known about the recreation hall that was built as part of the historic fire station complex. A brass WPA plaque is mounted onto the front of the building.

SAN JUAN CAPISTRANO HIGH SCHOOL (NOW SERRA HIGH SCHOOL)
31422 Camino Capistrano
San Juan Capistrano, CA 92675
Constructed: 1938–39
Architect: T.C. Kistner
An example of Streamline Moderne architecture, this high school building replaced structures that had been built in the 1920s. Originally, glass blocks had been used in place of windows, although these features have since been covered with stucco.

SANTA ANA CITY HALL
217 North Main Street
Santa Ana, CA 92701
Constructed: 1935
Architect: W. Horace Austin
This building served as Santa Ana's fourth city hall, from 1935 to 1973. An exceptional example of zigzag Art Deco, the large carvings above the entrance were inspired by ancient Mesopotamian figures. Today, the building is used as retail space and listened on the National Register of Historic Places.

Appendix

SANTA ANA HIGH SCHOOL
520 West Walnut Street
Santa Ana, CA 92701
Constructed: 1935–37
Architects: Allison & Allison
Santa Ana High School, which was built after the 1933 earthquake, still features several large buildings that were constructed as part of the New Deal in the mid-1930s. Allison & Allison's design is a combination of the monumental and zigzag forms of Art Deco. An engraving on the school's façade features the year of construction, 1935.

SANTIAGO PARK
2525 North Main Street
Santa Ana, CA 92705
Constructed: 1935–38
Although little evidence of New Deal improvement survives today, Santiago Park features similar stonework to nearby Hart Park as part of the widespread channelization of Santiago Creek.

SEAL BEACH ELEMENTARY SCHOOL
1190 Pacific Coast Highway
Seal Beach, CA 90740
Constructed: 1934–35
Architects: Marsh, Smith and Powell
Formerly the Seal Beach Elementary School, this building now houses retail space. The wall surrounding the complex was constructed with bricks from the original school destroyed by the 1933 Long Beach earthquake.

SEAL BEACH MUNICIPAL PIER
Ocean Avenue and Main Street
Seal Beach, CA 90740
Constructed: 1938–39
A plaque at the base of the pier commemorates the PWA money received to aid in the reconstruction of the city's original pier.

Appendix

Spurgeon Elementary School
(now Benjamin Franklin Elementary School)
210 West Cubbon Street
Santa Ana, CA 92701
Constructed: 1934
Architect: Frederick Eley

An all-but-forgotten New Deal landmark in Orange County, this school was reconstructed following the 1933 earthquake. The architect, Frederick Eley, was Orange County's first registered architect and very prolific in the first decades of the twentieth century. The school's name was changed from Spurgeon School to Franklin School in the mid-1970s.

Stone Field
31322 Camino Capistrano
San Juan Capistrano, CA 92675
Constructed: 1936–39

Similar to parks in Fullerton and Orange, Stone Field features rough-hewn rockwork that is indicative of the "WPA Rustic" style of architecture. The field was constructed at the same time as San Juan Capistrano High School.

Thomas Edison Elementary School
2063 Orange Avenue
Santa Ana, CA 92707
Constructed: 1936–37
Architect: Frederick Eley

One of two schools in Santa Ana that Frederick Eley designed during the New Deal, Thomas Edison Elementary School features energy-related reliefs on its façade in honor of its namesake. Today, the building retains much of its architectural integrity.

Valencia High School
(including Bradford Avenue Elementary School)
500 Bradford Avenue
Placentia, CA 92870
Constructed: 1935–38
Architect: T.C. Kistner

Valencia High School (whose campus also includes the former Bradford Avenue Elementary School) features a large collection of New Deal buildings, all designed by the same architect. The administration building and gymnasium of the high school, as well as the classroom building and auditorium of the elementary school, are all designed in a similar, cohesive Streamline style.

Appendix

Wilshire Junior High School
315 East Wilshire Avenue
Fullerton, CA 92832
Constructed: 1934–36

Similar in appearance to Maple Elementary School, the former Wilshire Junior High School consists of three buildings constructed during the New Deal. Today, it is part of the School of Continuing Education.

Additional Reading

Bitetti, Marge, and the Santa Ana Historical Preservation Society. *Early Santa Ana.* Charleston, SC: Arcadia Publishing, 2006.

Bushman, John. "The New Deal in Orange County." Orange County Historical Society *County Courier*, 2011.

Epting, Chris. *Huntington Beach, California.* Charleston, SC: Arcadia Publishing, 2001.

Federal Writers' Project. *California: A Guide to the Golden State.* New York: Hastings House, 1939.

Fullerton Public Library. *Fullerton.* Charleston, SC: Arcadia Publishing, 2004.

Gray, Pamela Lee. *Newport Beach.* Charleston, SC: Arcadia Publishing, 2003.

Huntington Beach News, various issues.

Los Angeles Times, various issues.

INDEX

A

Ahring, Jaine 38, 130
Allison & Allison 22, 23, 25, 33, 95, 101, 125, 127, 128, 133
American Guide Series 112
Amerige Park 54, 58, 60, 107, 113, 123
Ames, Arthur 36, 75, 84, 112, 124, 130
Amory, H. Russell 51
Anaheim High School 69, 123
Anaheim Landing 21
Anaheim Library 84
Anaheim Muzeo 81
Anaheim Post Office 79, 90
archeological excavations 119
Armitage, Merle 82
Austin, W. Horace 42, 62, 94, 124, 131, 132

B

Baker Street School 65
Balboa Island 35
Bates, Richard M., Jr. 78, 129
Benjamin Franklin Elementary School (Anaheim) 75, 124
Benjamin Franklin Elementary School (Santa Ana) 96, 134
Black Star Canyon 120
Bowers Museum 111
Bradford Avenue Elementary School 63, 134
Brea Grammar School 66, 124
Brea-Olinda High School 66
Bristol, W.J. 22
Broadway School 77
Buena Park 43

C

California Pacific International Exposition 23
California Valencia Orange Fair 86
Centralia School 78
Chambers, H.C. 44
Chapman School 45
Citron School 74
Civilian Conservation Corps 9, 11, 12, 104, 107, 108, 125
Civil Works Administration 12, 19, 21, 23, 27, 28, 29, 48, 58, 60, 70, 86, 99, 116, 122

INDEX

Colburn, Eleanor 102
Collins, Samuel L. 53
Cornell, Ralph D. 48
Costa Mesa Fire Station 41
Costa Mesa Grammar School 40
Cypress School 42, 124

D

Doheny State Beach 109, 125
Durfee, M. Eugene 90
Dwyer Middle School 23, 125

E

Edison Elementary School 17, 97, 134
Eisen, Percy A. 25, 30
Eley, Frederick H. 79, 89, 97, 100, 126, 134

F

Federal Art Project 12, 36, 38, 57, 75, 112, 114
Federal Emergency Relief Act 12, 14, 34
Federal Music Project 115
Federal Project Number One 112
Federal Theater Project 113
Federal Writers' Project 112
Field Act 15
Ford Avenue School 44
Fullerton City Hall 54, 125
Fullerton College 48, 125
Fullerton High School 47
Fullerton Library 51, 126
Fullerton Museum Center 51, 126
Fullerton Post Office 51, 126

G

Garden Grove High School 99, 126
George Washington Elementary School 77
Gladding, McBean and Company 55
Goodwin, Jean 36, 112, 130
Griggs, Dale 99

H

Hart Park 58, 87, 97, 107, 131
Hillcrest Park 57, 60, 112, 127
Historical Records Survey 113
Historic American Buildings Survey 118
Hopkins, Harry 12
Horace Mann Elementary School 78
Huntington Beach Fire Station 25
Huntington Beach Grammar School 22
Huntington Beach High School 25, 127
Huntington Beach Memorial Hall 25
Huntington Beach Pier 32, 127
Huntington Beach Post Office 26, 90, 127
Hunt, Myron 44
Huston, J. Ed 26

I

Ickes, Harold L. 11, 103
Irvine Park 89, 128

J

John C. Fremont School 73
Julian, Paul 53, 126
Junipero Serra High School 104

K

Kassler, Charles, Jr. 47, 53, 57, 131
Kinch, Myra 114
Kirby, D.B. 38, 130
Kistner, Theodore C. 63, 65, 66, 70, 99, 105, 123, 124, 132, 134

L

Laguna Beach Elementary School 101, 128
Laguna Beach High School 101, 115, 128
Laguna Beach Post Office 103, 128
Laguna Beach Sewage Treatment Plant 122
La Habra Historical Museum 61

Index

La Habra Library 61, 128
La Jolla Junior High School 65
Lake Park 26, 129
La Palma Park 84, 129
La Palma School 78
Laurel Elementary School 129
Laurel School 66
LeGage, A.F. 94
Legg, Herbert C. 62, 86
Limestone Canyon 120
Lincoln School 78
Loara Elementary School 78, 129
Long Beach Earthquake of 1933 14
Los Angeles Flood of 1938 15
Louis E. Plummer Auditorium 47, 131
Lundeberg, Helen 57, 112, 125

M

Mackie, H.E. 33
Maier-Krieg, Eugene 81, 126
Mann, Charles H. 79
Maple Elementary School 129
Maple Street School 44
Marsh, Smith and Powell 21, 74, 75, 124, 133
McComb, Dana Q. 79
McDonald, J.K. 27
McGaugh, J.H. 21
Mission San Juan Capistrano 118
Modjeska, Helena 81, 113, 126

N

Newland House 120
Newport Beach Breakwater 35
Newport Beach Elementary School 130
Newport Beach Grammar School 38
Newport Harbor High School 36, 130
Newport Harbor improvements 33, 35, 130

O

Ocean Front Park 27, 29, 32
Olive Civic Center 92, 130
Olive Grammar School 92
Orange City Park 86, 131
Orange County Courthouse 94
Orange County Harbor District 34
Orange County Hospital 90
Orange Plaza 92
Orange Post Office 89, 131

P

Parks, Everett E. 44, 129
Patterson, R.L. 34
Pav-A-Lon Ballroom 25, 30
Pearson Park 81
Peterson, Charles E. 116
Pioneer House of the Mother Colony 118
Placentia City Hall 62, 131
Plummer, Louis E. 48
Public Works of Art Project 12, 47, 81, 84, 102, 112

R

Reconstruction Finance Corporation 21, 22, 27, 29, 58, 70
Robins Hall 38
Roosevelt, Franklin Delano 9, 11, 14, 54, 60, 74, 109, 111

S

San Clemente State Beach 109, 132
San Juan Capistrano Fire Station 107, 132
San Juan Capistrano High School 104, 132
Santa Ana City Hall 17, 93, 132
Santa Ana Flood of 1937 15
Santa Ana High School 94, 115, 133
Santa Ana Municipal Bowl 99
Santiago Creek 86, 87, 89, 97
Santiago Park 97, 133
Seal Beach Breakwater 21
Seal Beach Elementary School 21, 133
Seal Beach Pier 18, 133

Seal Beach Sewage Treatment Plan 120
Section of Painting and Sculpture 12, 53, 126
Sheffield House 118
Silverado Elementary School 107
Simon, Louis A. 53, 90, 126, 127, 131
Soderberg, Marc 61
Spangler, Fay R. 92, 130
Spurgeon School 97, 134
Standard Oil Company 22
State Emergency Relief Administration 14, 23, 29, 48, 58, 61, 65, 70, 81, 86, 99, 120
Stone Field 58, 107, 134

T

Talbert, Thomas B. 26
Thomas Edison Elementary School 96
Tropical Storm of 1939 16, 32
Tustin Elementary School 93

U

University of California, Irvine 120

V

Valencia High School 65, 134
Valencia School 45
Vaughn, Harry K. 48, 51, 125, 126
Von KleinSmid, Dr. Rufus B. 51

W

Walker, Albert R. 25, 30
Wallace, Lew H. 34
West Coast Dance Project 114
Westminster Elementary School 33
Whitaker, J.H. 79
Wildman, H.C. 42, 62, 124, 131
Wilshire Junior High School 45, 135
Wilson, George Stanley 54, 125

Y

Yorba Linda 68

About the Author

Born in Santa Monica and raised in Huntington Beach, California, Charles Epting is an undergraduate student at the University of Southern California. He is studying history, geology and environmental studies and for several years has been a volunteer at the Los Angeles County Museum of Natural History, where he studies paleontology. He is the author of *University Park, Los Angeles*.

Visit us at
www.historypress.net
...
This title is also available as an e-book